YOUNG ARTISTS
DRAW ANIMALS

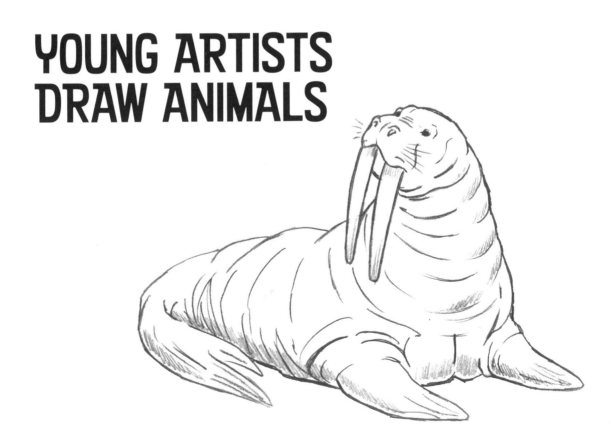

YOUNG ARTISTS
DRAW ANIMALS

Christopher Hart

Watson-Guptill Publications / New York

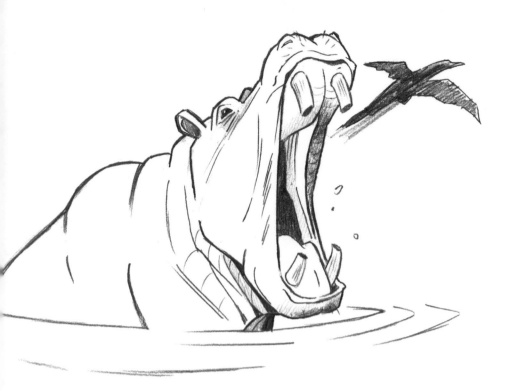

Published in the United States
by Watson-Guptill Publications,
an imprint of the Crown Publishing Group,
a division of Random House, Inc., New York
www.crownpublishing.com
www.watsonguptill.com

WATSON-GUPTILL and the WG and Horse designs
are registered trademarks of Random House, Inc.

Library of Congress Cataloging-in-Publication Data
Hart, Christopher, 1957–
 Young artists draw animals / Christopher Hart — 1st ed/
 p. cm.
1. Animals in art—Juvenile literature. 2. Drawing—Technique—
Juvenile literature.
 NC780.H263 2012
 743.6 2011045546

ISBN 978-0-8230-0718-9
eISBN 978-0-8230-0719-6

Cover design by Jess Morphew
Cover art by Christopher Hart
Interior design by Karla Baker

Printed in China
10 9 8 7 6 5 4 3 2 1
First Edition

Dedicated to all aspiring artists everywhere!

—your drawing pal,
Christopher Hart

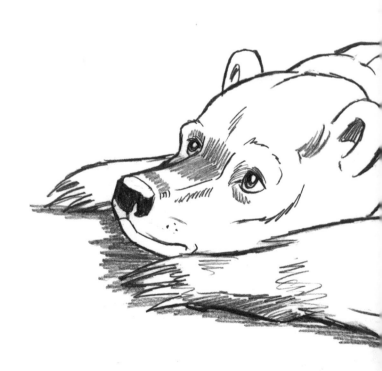

CONTENTS

INTRODUCTION

Animals are fun to draw, but they can be challenging subjects. This book makes it both fun and easy to draw all sorts of creatures. We'll start off with a brief, illustrated overview that highlights the important differences between human and animal anatomy. Then we'll dive into drawing a huge variety of popular animals.

Each animal in the book can be drawn from six easy-to-follow instructional steps based on shapes that anyone can duplicate. Little by little, you'll add details to these shapes until the animal is complete. With clear instructions like these, you'll be drawing animals faster than you ever thought possible.

Many peculiar creatures are in here, like the gecko, the anteater, and even the strange-looking, superpoisonous lionfish. Everyone's favorite animals are still here in abundance, however, so you'll also find examples of bears, horses, dogs, and cats! In addition, there are chapters on farm animals, reptiles, and even the largest animals of Africa.

I'll show you how to re-create classic animal poses in order to give your drawings maximum appeal. For example, an eager dog typically looks up at its owner with its tongue out and its tail wagging, a tiger slinks around stealthily, and so forth.

To begin having fun and learning new things, all you need is a pencil and some paper. So let's get started drawing animals from all over the world, from the chilly North Pole to the hot savannas of Africa!

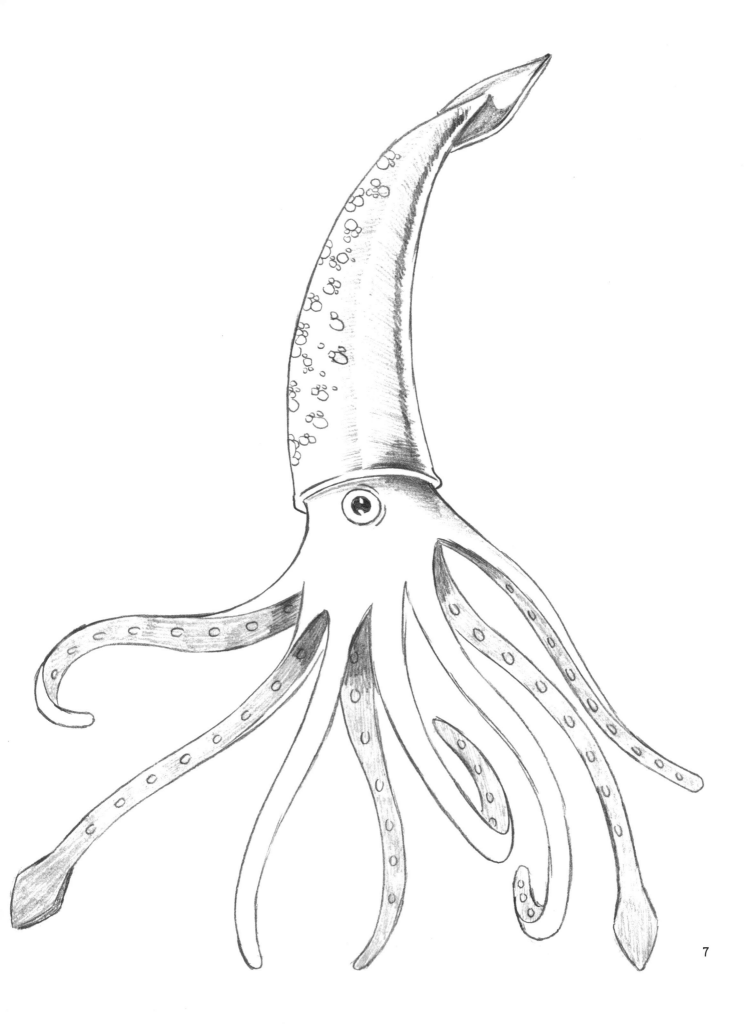

DRAWING BASICS

You probably have a basic sense of human anatomy already—you know where the shoulder is, as well as the elbow, the forehead, and so on. But when it comes to drawing animals, this anatomy changes. Sure, animals still have the same parts as we do, such as eyes, ears, noses, and mouths. But these features are positioned differently on animals' heads and bodies, and they lie at different angles. Seeing how animals differ from us is the key to learning how to draw them. So, let's take a look at a few important differences.

Drawing details is fun, but professional artists generally begin with the larger, simpler shapes to create a foundation first. Once that's in place, they add the details—and it's still fun!

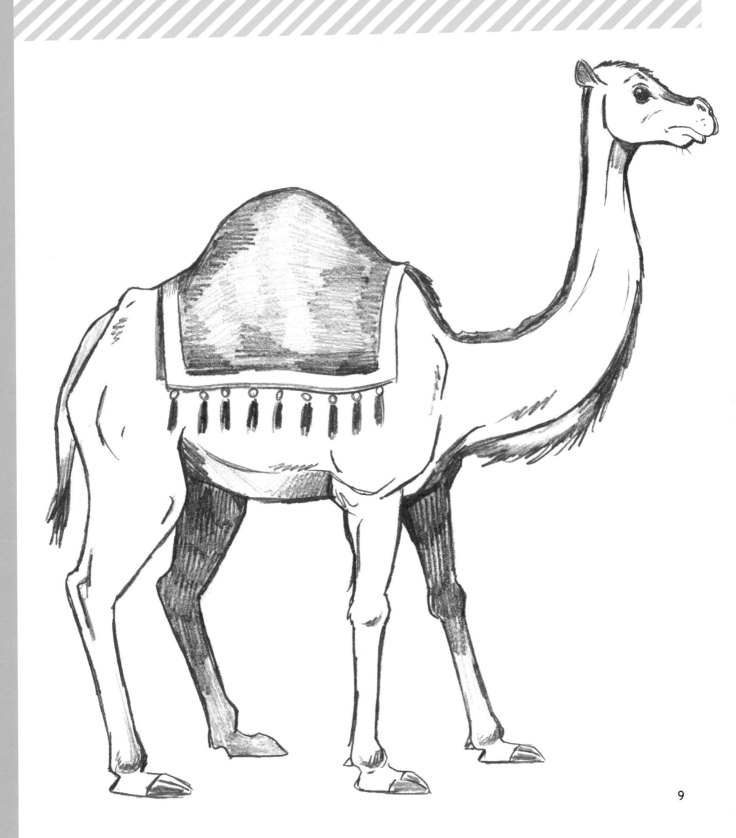

DRAWiNG THE HEAD

One of the first things an artist becomes aware of when drawing an animal is that the animal body—especially what we would regard as the "arms" and "legs"—is configured quite differently from that of humans. The differences in the head shape may be a little subtler, which is why some beginners overlook them. In comparing the human head to an animal head, we notice that, other than the nose and the shape of the ears, everything else is built in pretty much the same way as it is with people. However, on closer inspection, we'll see that it is not so much the actual features of the head but where they are placed—and in what proportion—that makes all the difference.

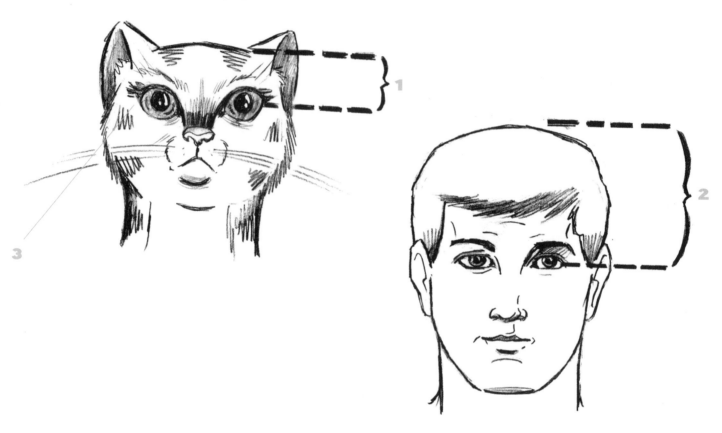

1 Notice that the forehead on most four-legged animals is small compared to the human forehead.

2 Humans have large foreheads. That's because our brains are so big.

3 Because animals have small foreheads, their eyes are positioned near the top of the head. Humans, who have large foreheads, have eyes that are closer to the middle of the head.

DRAWING THE EYES

To be good hunters, carnivores need extra-sharp vision that focuses straight ahead at their prey. Therefore, their eyes are spaced closely together. Do you know what other animal has eyes that are spaced closely together? Man.

Herbivores only eat plants. To avoid falling victim to hunters and carnivores, they must constantly be aware of their surroundings. Therefore, they possess superb peripheral vision that helps them see threats coming from all directions. To have highly developed peripheral vision, their eyes must be spaced widely apart on their head.

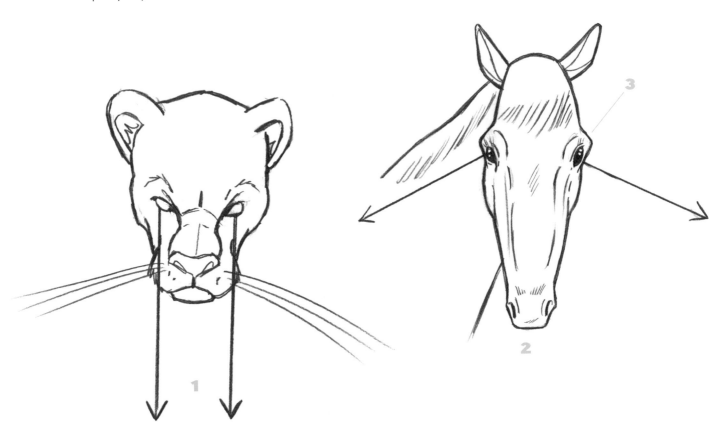

LION

1 A predator's eyes sit closely together and look straight ahead.

HORSE

2 An herbivore's eyes are spaced widely apart, lie on a diagonal, and look off to the sides.

3 Notice how the eye sockets bulge outward in order to encircle and protect the widely placed eyes.

DRAWiNG THE EARS

Here's a little hint that will show you exactly where to place animal ears. Almost all animals have one thing in common: Their ears are positioned at a diagonal to the head, whereas human ears are positioned on the sides of the head. You'll also notice that human ears are generally placed much lower on the head than animal ears.

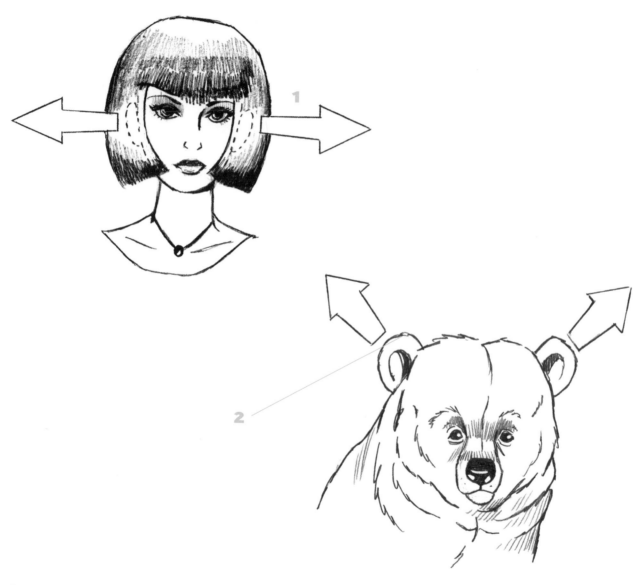

1 Human ears are attached to the side of the head and point straight out.

2 Animal ears are attached to the head at an angle, and therefore, point outward at a diagonal. Notice the difference?

HOLD YOUR HEAD UP—OR NOT?

If your mom is like my mom, she always tells you to stop slouching and hold your head up when you walk. That's good advice for humans but not for animals. Often, you'll find that the more massive an animal's head is, the lower it hangs. Therefore, it's also no coincidence that the larger an animal's head is, the thicker its neck will be. A huge head has a massive, heavy skull that requires strong muscles to support it.

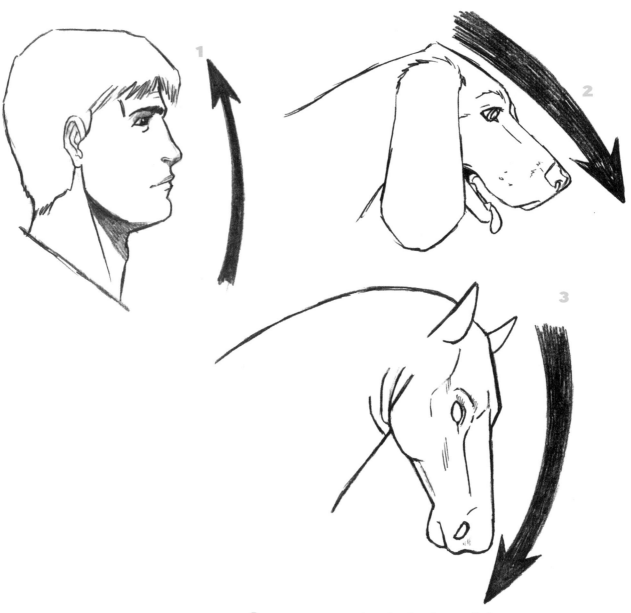

1 Humans hold their heads high (unless they have gotten a bad grade, dented their dad's car, or have done something else they're trying to hide).

2 The heads of dogs (and other medium-size animals) tilt down slightly.

3 Massive animals' heads often hang quite low. But here's a curious fact: One extremely massive animal's head doesn't hang low at all. Can you guess which one that is, and why? It's the elephant. Its head doesn't hang low because an elephant's neck is so short that its head seems fused to its body.

DRAWING BODIES

When drawing bodies, you may find it more effective to draw the entire basic structure first rather than starting and completing each section of the animal as you go. Here are some quick tips for drawing animals:

- Use more curved lines than straight lines.

- Make sure each limb has the same amount of joints as every other limb.

- An animal's body will rarely be perfectly symmetrical. Most often, it will be slightly uneven. For example, the tummy might be a bit larger than the chest, the shoulders might be a little higher than the hips, or the thigh muscle might be slightly bigger than the shoulder muscle—that sort of thing.

MORE HINTS

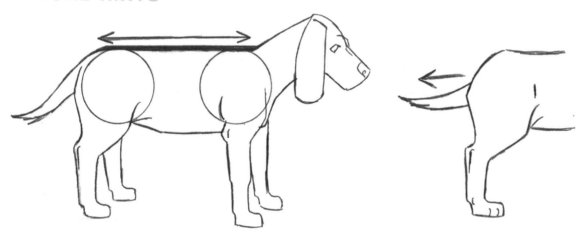

Try to limit the use of straight lines.

The tail is not "pasted" onto the rump.

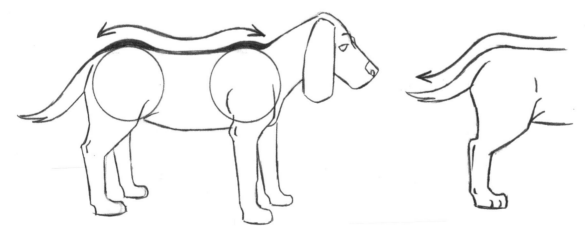

See how curved lines look more natural?

The tail travels off the rump in a single, sweeping line.

SiMPLiFiED ANATOMY OF A HORSE

A horse's anatomy is similar to that of most mammals, such as dogs, cats, pigs, and deer. Other mammals, both big and small, have bones that are angled the same way as the horse's are. It's interesting to take a look. You don't have to draw this. Just observe it to get the overall concept.

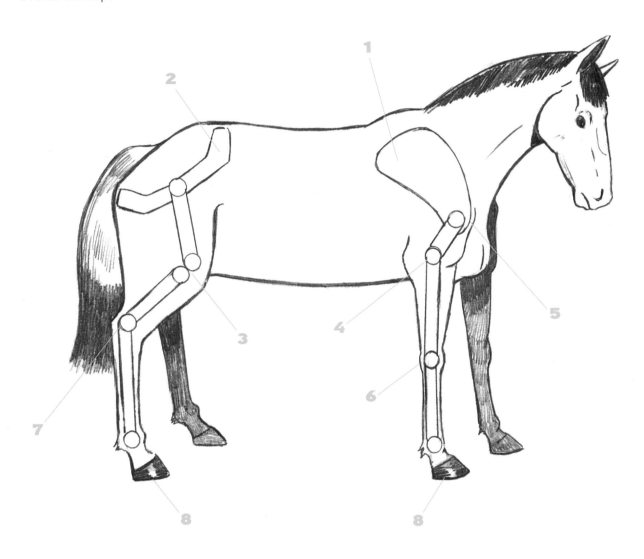

1	Shoulder blade	5	Shoulder
2	Hip	6	Wrist
3	Knee	7	Heel
4	Elbow	8	Toenail (Yep, the hoof is actually one big toenail!)

ANGLES OF THE BODY

No two animals are alike, but some do have similar body shapes. When drawing animals, try to emphasize the angles of the body. Most mammals' necks curve, while their hips slant downward toward their hind legs. On the other hand, the bodies of fish and amphibians are slightly oval-shaped, tapering in toward their tails or tail fins.

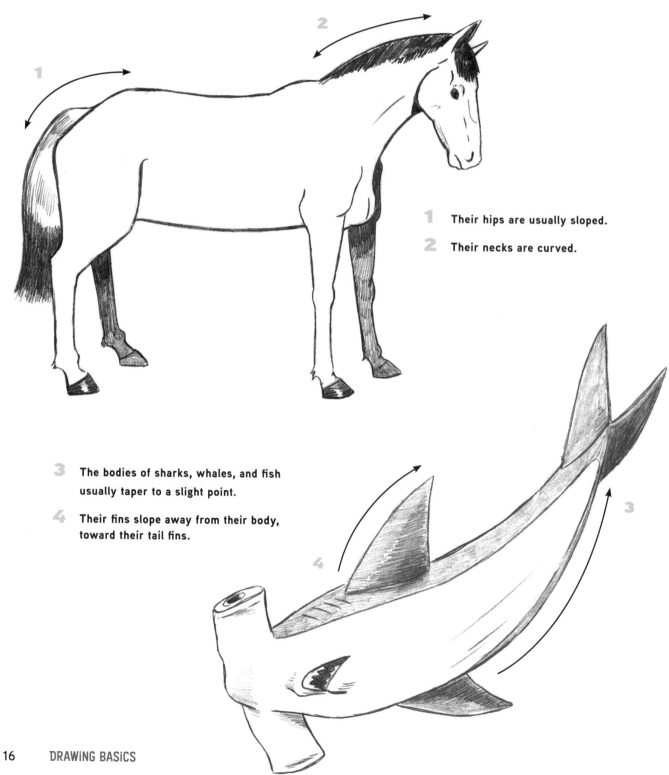

1 Their hips are usually sloped.

2 Their necks are curved.

3 The bodies of sharks, whales, and fish usually taper to a slight point.

4 Their fins slope away from their body, toward their tail fins.

HOOVES AND PAWS

Drawing animals' various hooves and paws can be tricky—but never fear! Here are some hints for drawing any kind of hoof or paw, no matter what animal you're drawing. These basic structures can be applied to most animals.

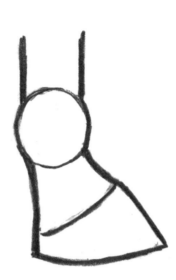

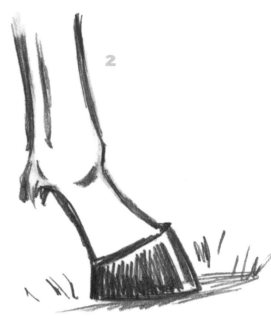

1 Notice the basic construction of the hoof.

2 Here's the finished version. You can still see the solid construction underneath.

3 Paws are round. A few straight lines map out the toes.

4 The toes are rounded at the top.

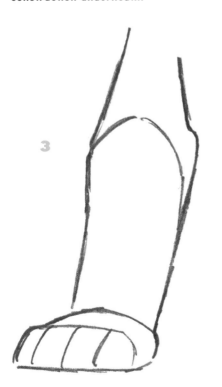

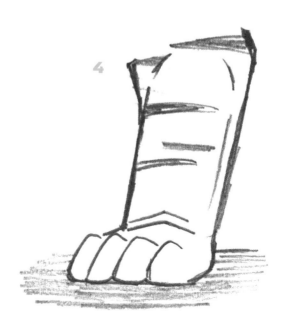

THE ANIMALS

Ready to start drawing animals? Get out your pencils! If you make some mistakes along the way, don't worry, and don't start over. Sketching and redrawing are what illustrating is all about. Every creature has slight differences, even within the same species. Therefore, it's fine—and expected—if your drawing looks somewhat different than mine.

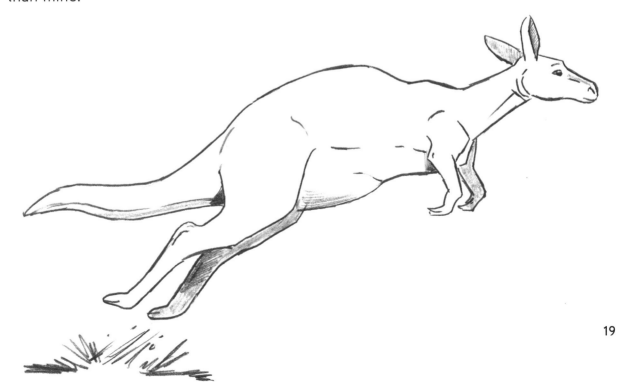

FARM ANiMALS

Farm animals make ideal picture-book and ani-
mated characters. If there's a cartoonist lurking in
you, these realistic drawings will provide you with
the source material you need, since cartoonists
often refer to the actual animals before inventing
cartoons based on them. By observing their
prominent features, whether it's a snout, a fluffy
tail, or special markings, the cartoonist transforms
them, through humorous exaggeration, into a fully
developed character. Farm animals vary widely in
size and shape, from a little bunny to a full-size
cow. But most are already somewhat familiar to us,
which helps in drawing them.

Sheep

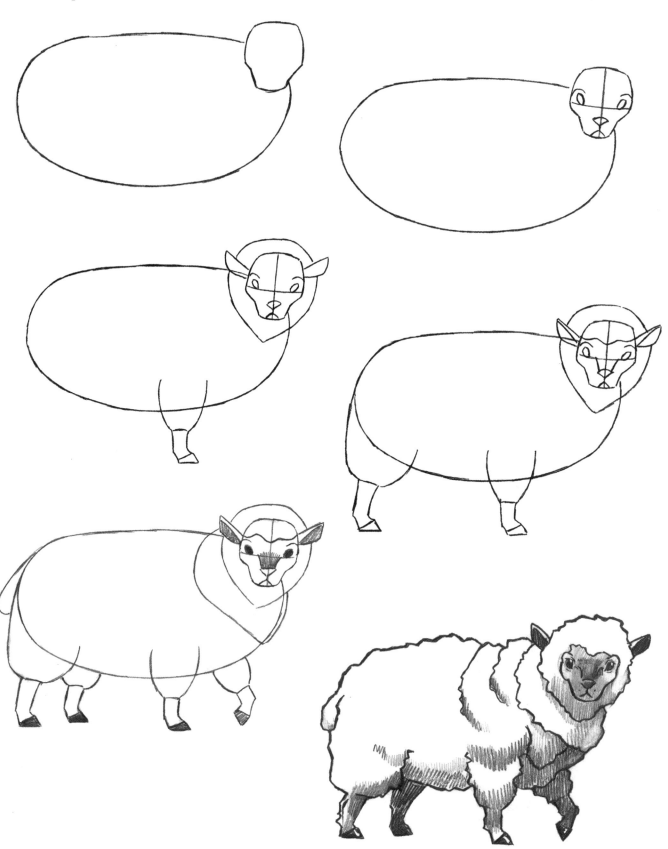

Goat

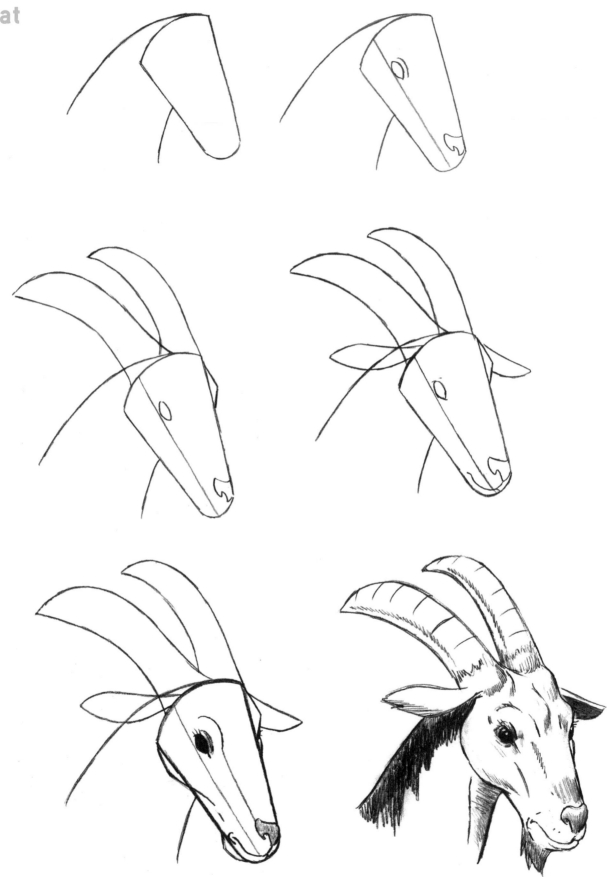

Pig

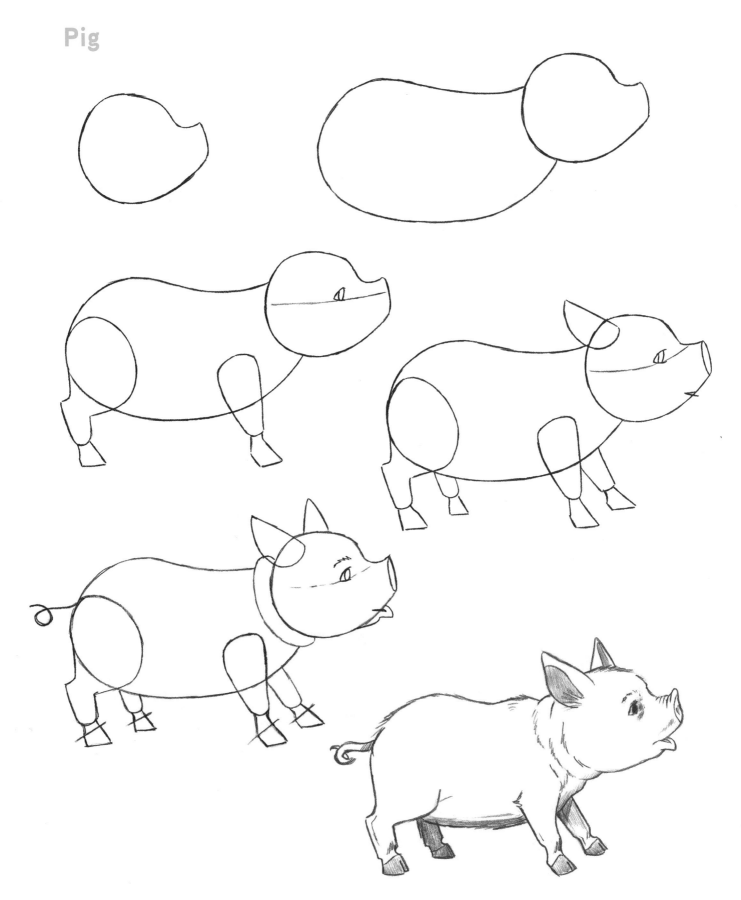

Rabbit

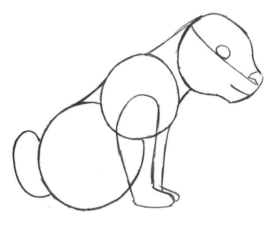

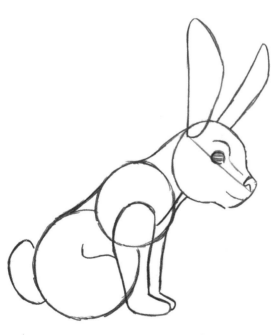

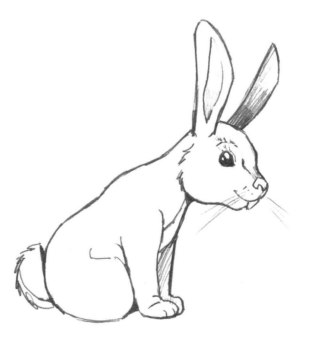

Mouse

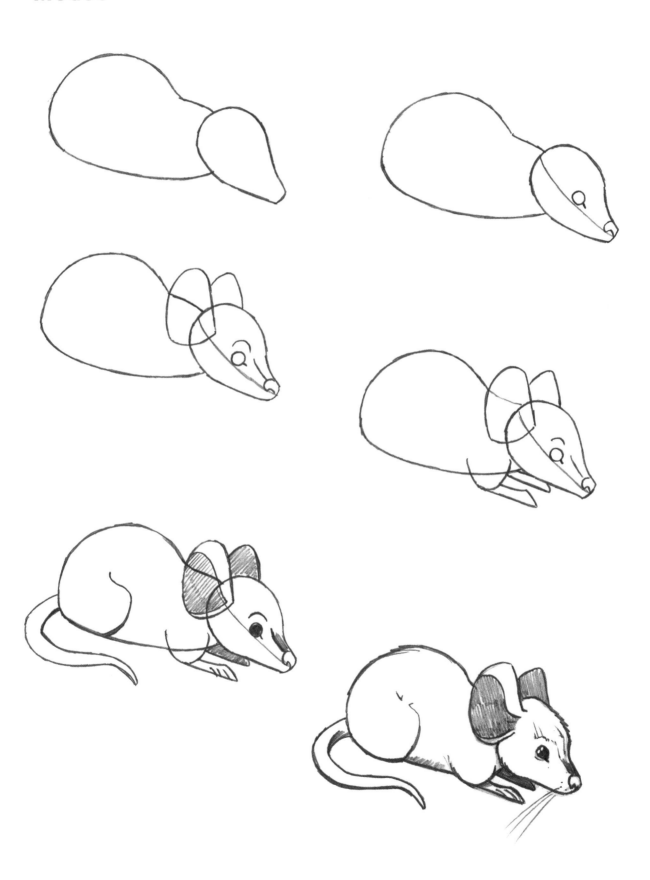

Cow

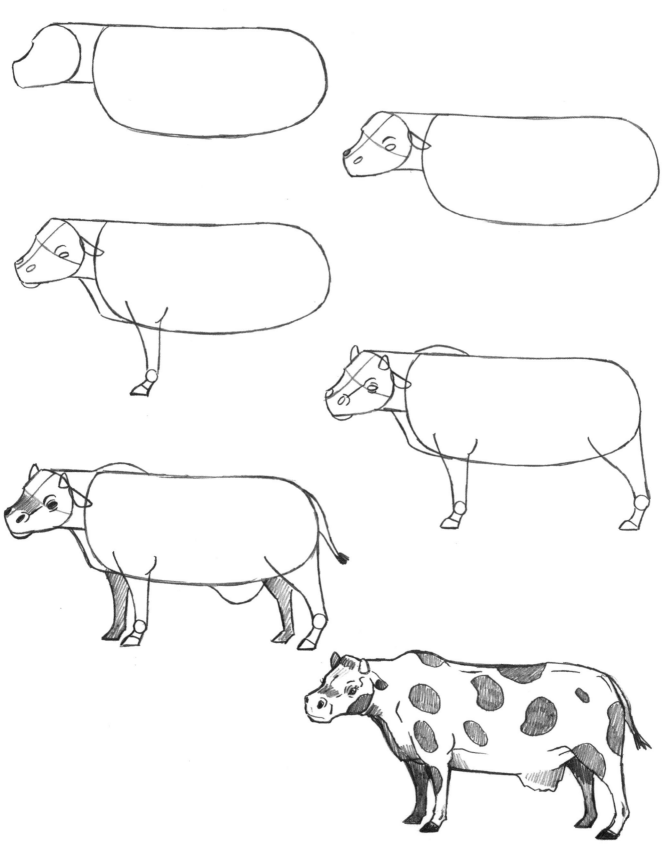

Bull

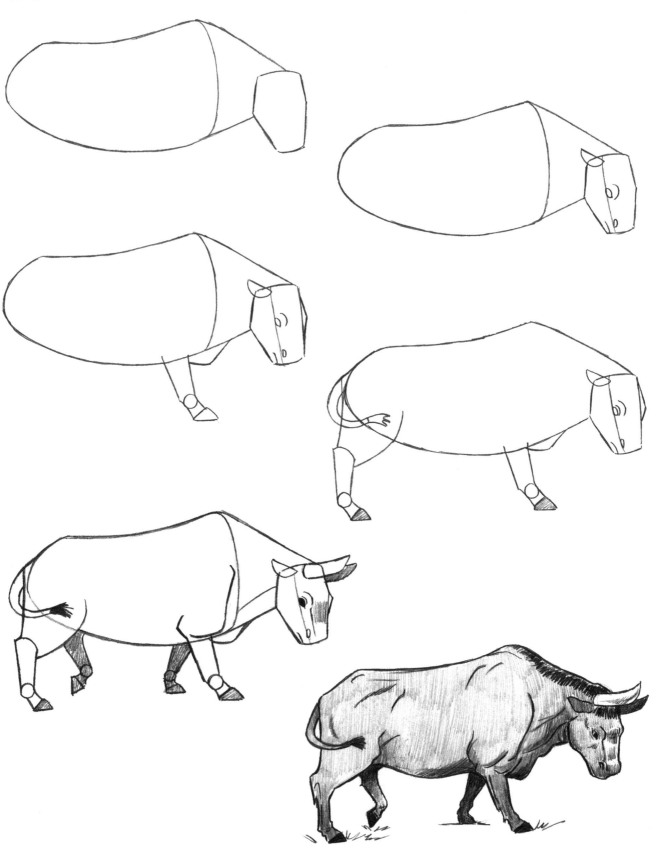

NORTH AMERICAN ANiMALS

North America is home to a wide variety of fascinating critters, including many that live in the woods. These foraging creatures are quite charming, and each seems to have its own personality. For example, there's the ever-busy beaver, the sly raccoon, and the cute but nervous squirrel. Some of the animals in this section, such as deer, remain alert and use quick movements to defend themselves, while others, like the porcupine and skunk, have built-in weapons. The largest herbivores in North America are hoofed animals like bison and deer. You may have seen deer where you live, as suburbs and towns begin to encroach on their natural habitat. But I believe that the deer in my neighborhood actually prefer the 'burbs during the winter, where their only good meal comes from the shrubs around my neighbors' houses!

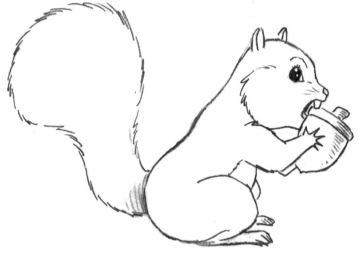

Beaver

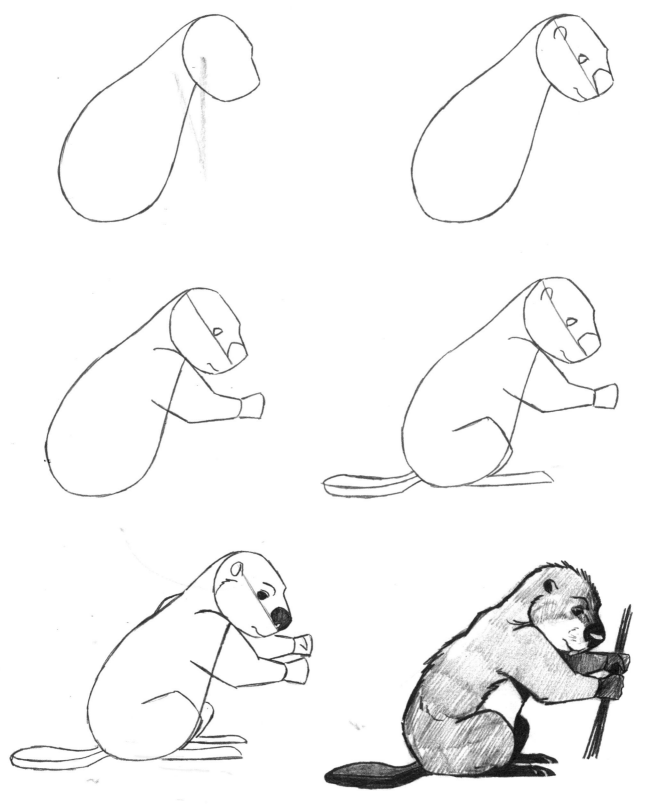

Squirrel

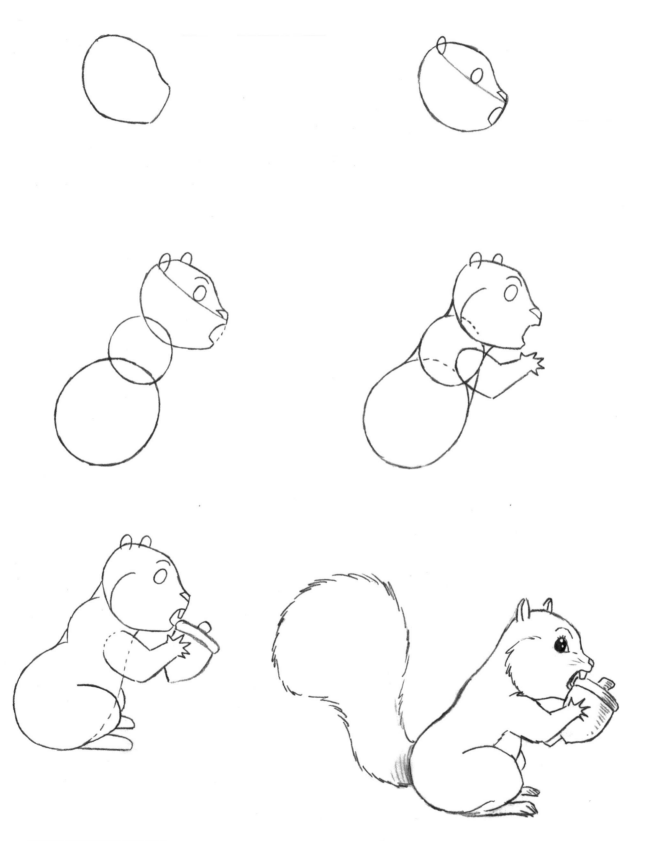

Raccoon

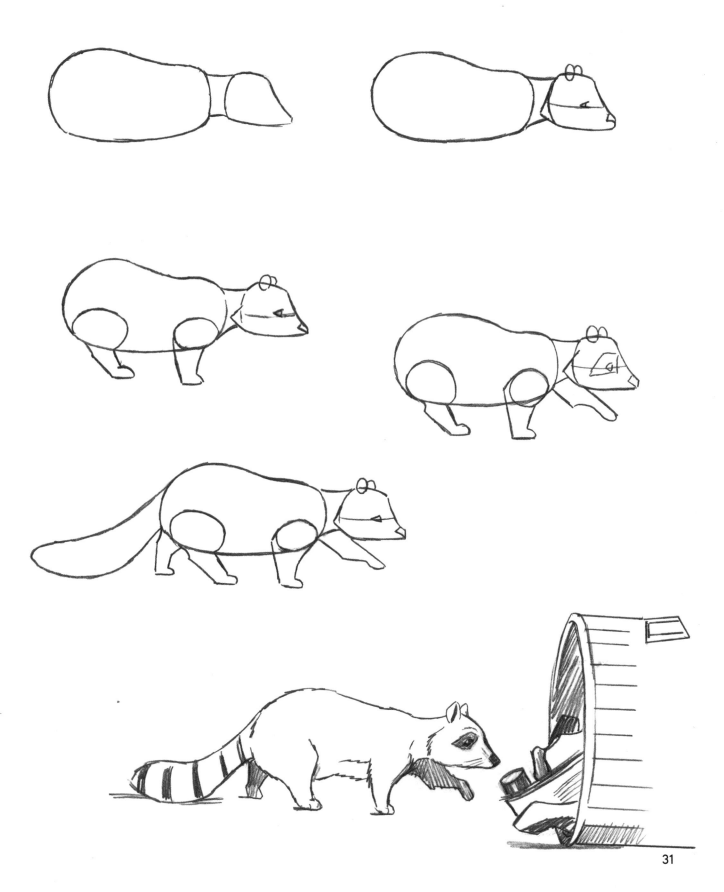

Porcupine

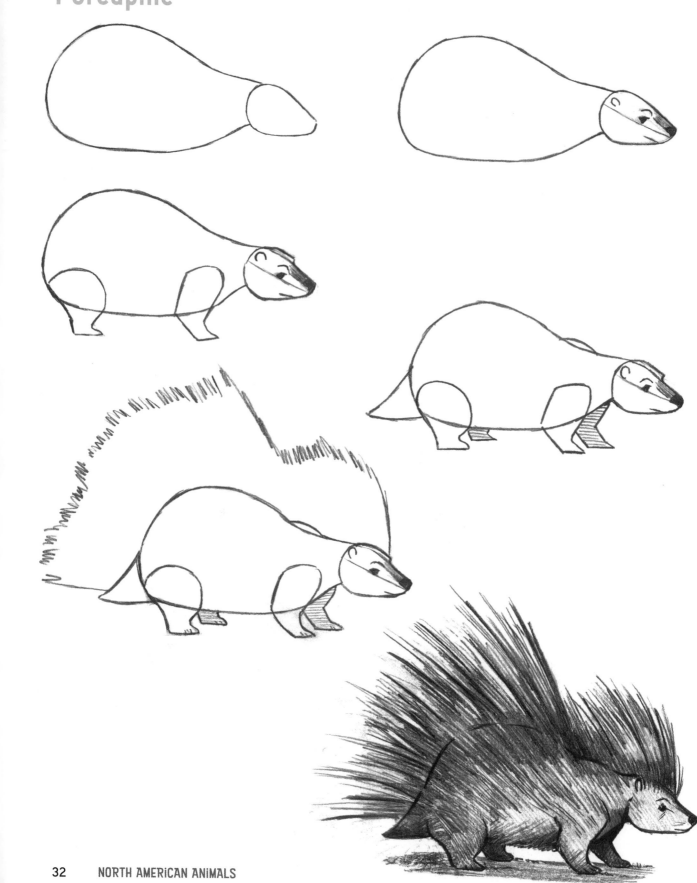

Skunk

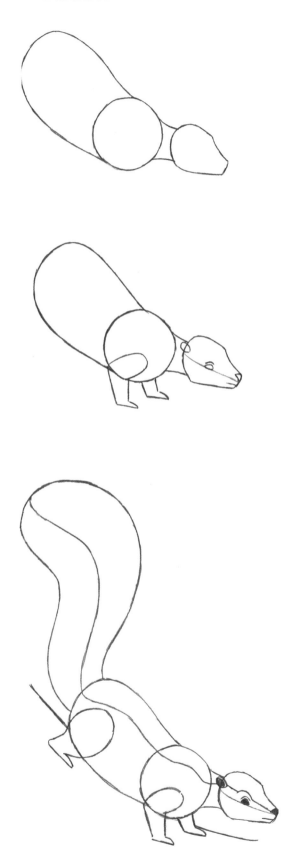
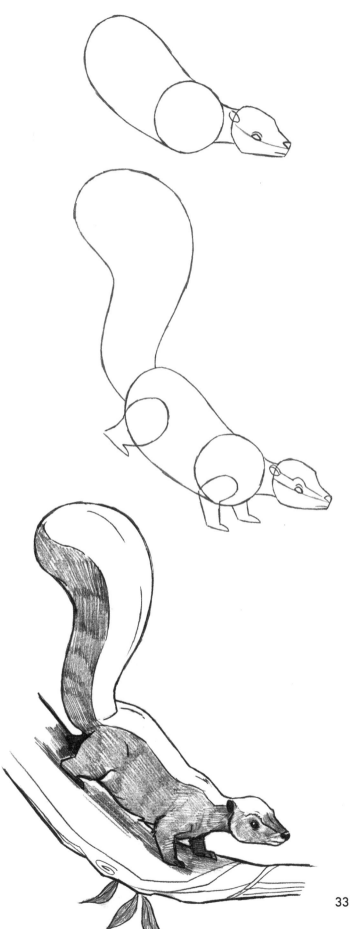

Deer

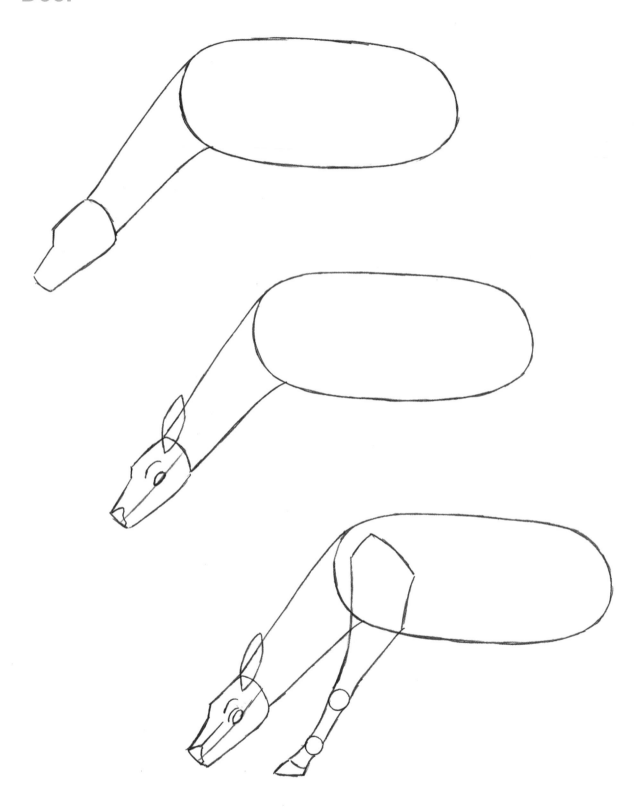

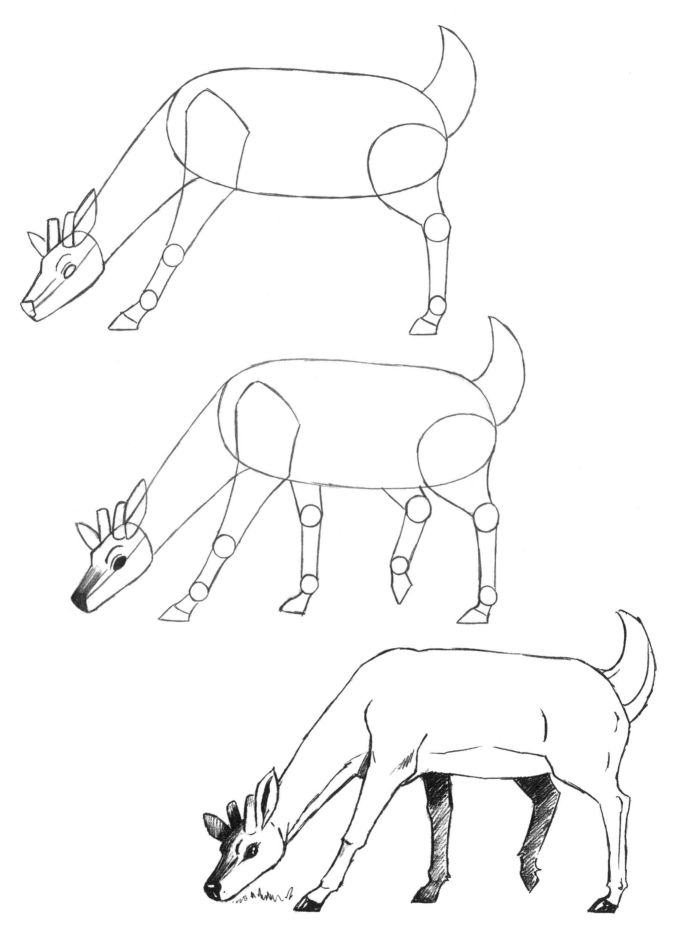

Bison

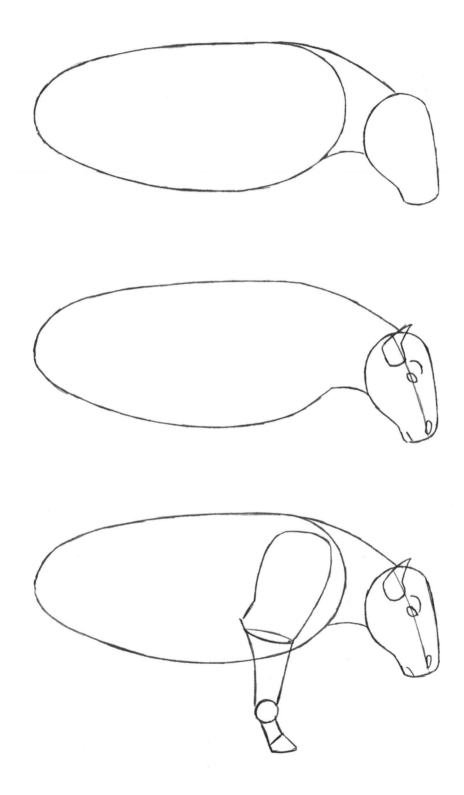

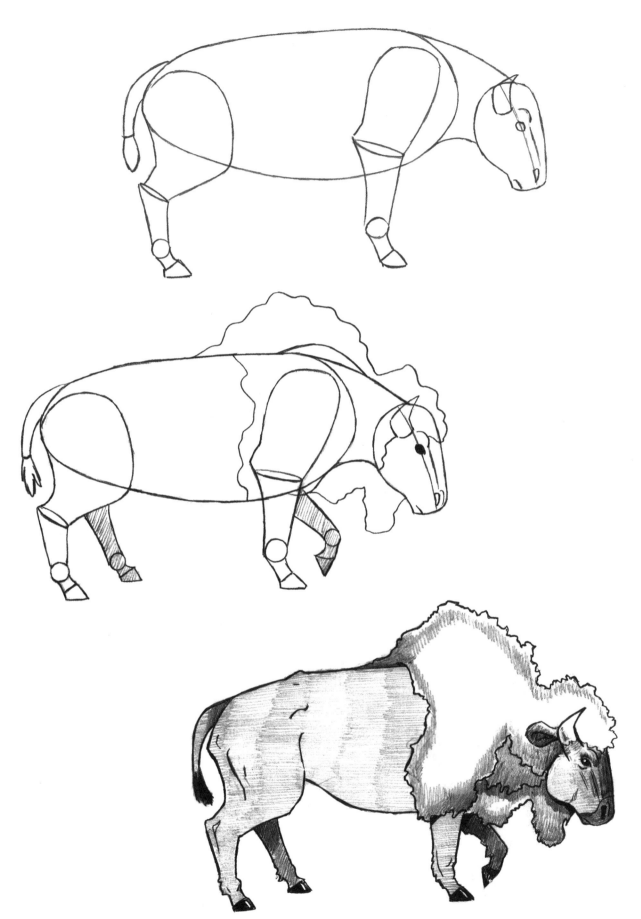

REPTiLES

Reptiles can be a bit tricky to draw, because they are so unusual looking. But that's part of their appeal. Their heads and bodies are built quite differently from a mammal's. They also move more slowly, unless they have to act quickly in order to catch their prey. They are reminiscent of dinosaurs, due in part to their scaly skin. Their eyes are typically spaced widely apart, and generally they have a long, slinky tail; a large mouth; and a long torso. Some of them also have very long, thin fingers and toes that add to their wonderfully creepy appearance. Reptiles can be among the most deadly animals on Earth, like the cobra, or the most harmless, like the frog.

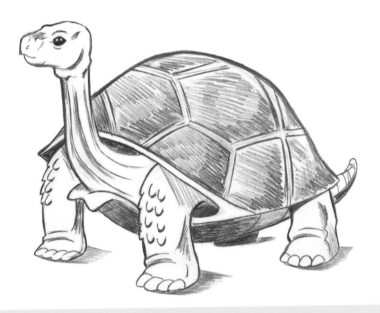

Cobra

Gecko

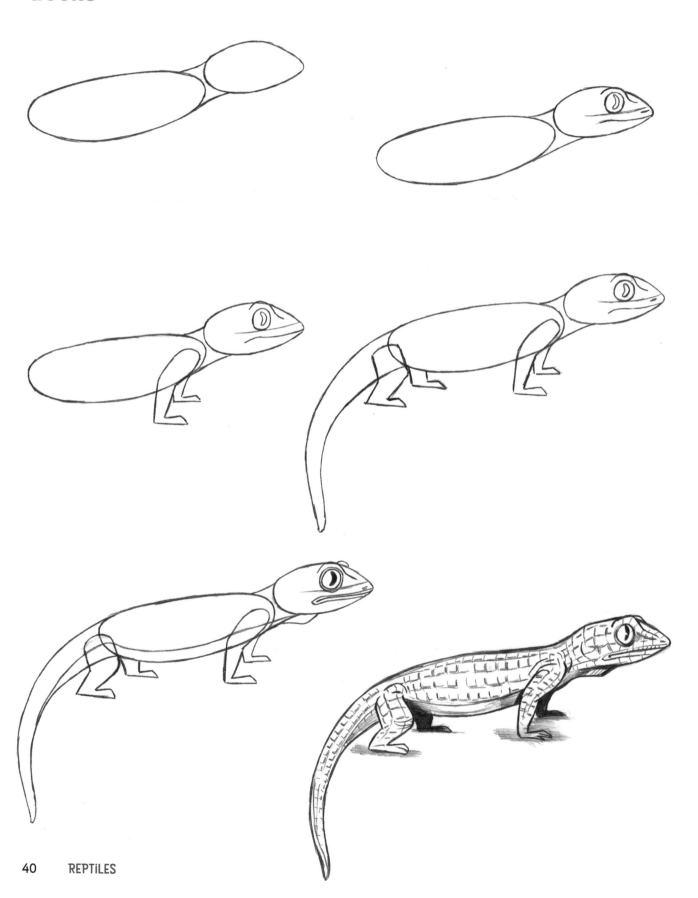

Frog

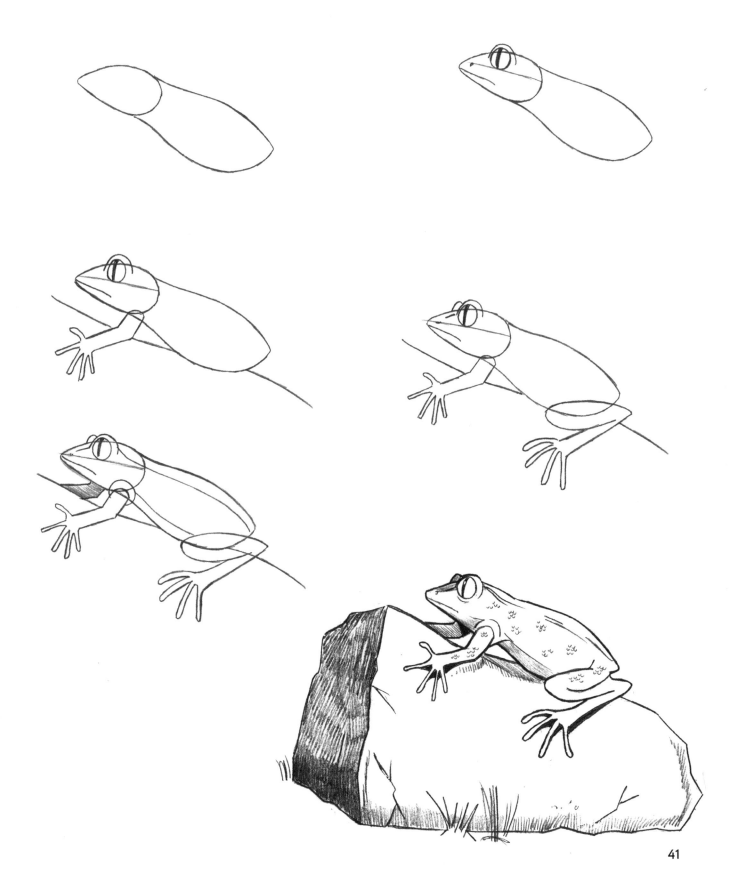

Alligator

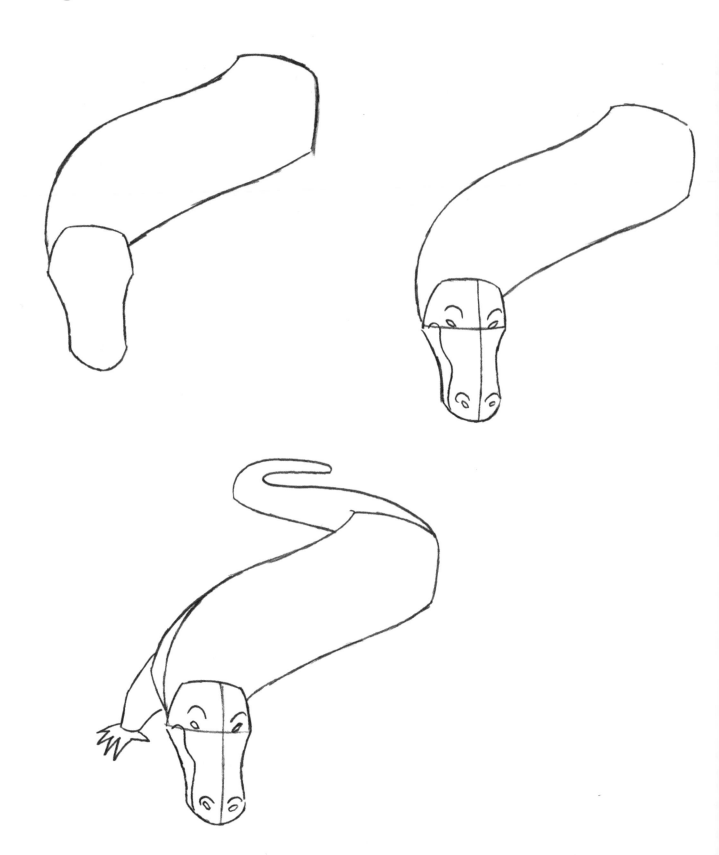

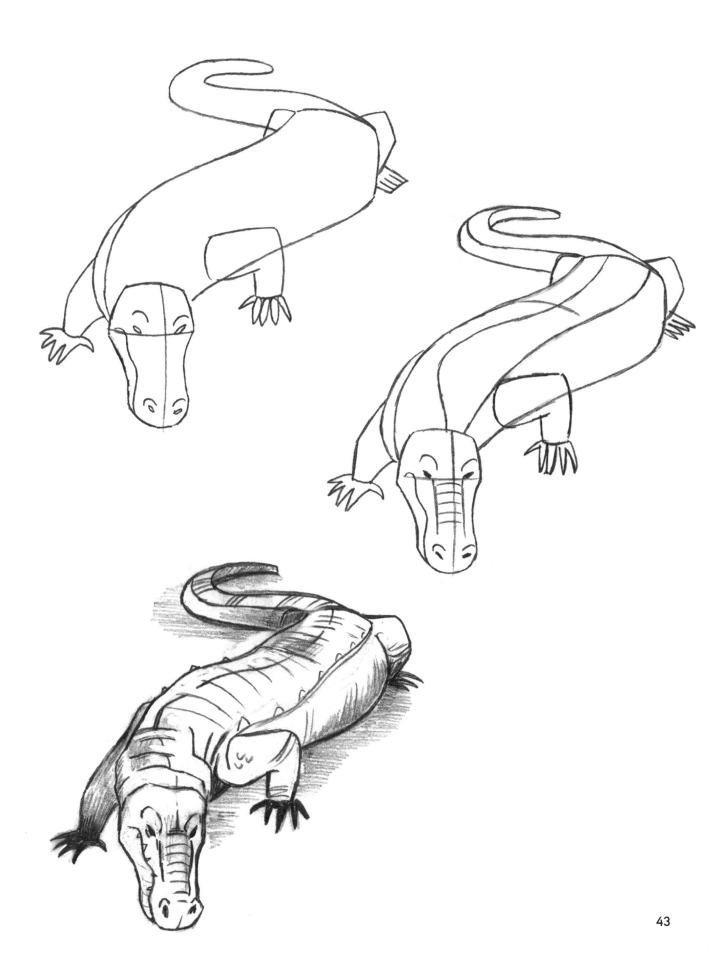

Tortoise

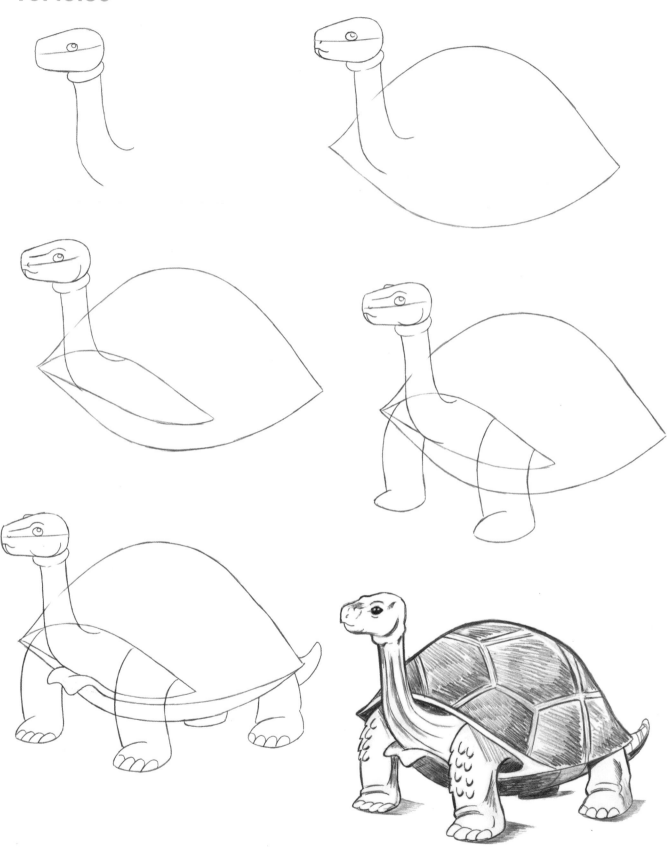

Iguana

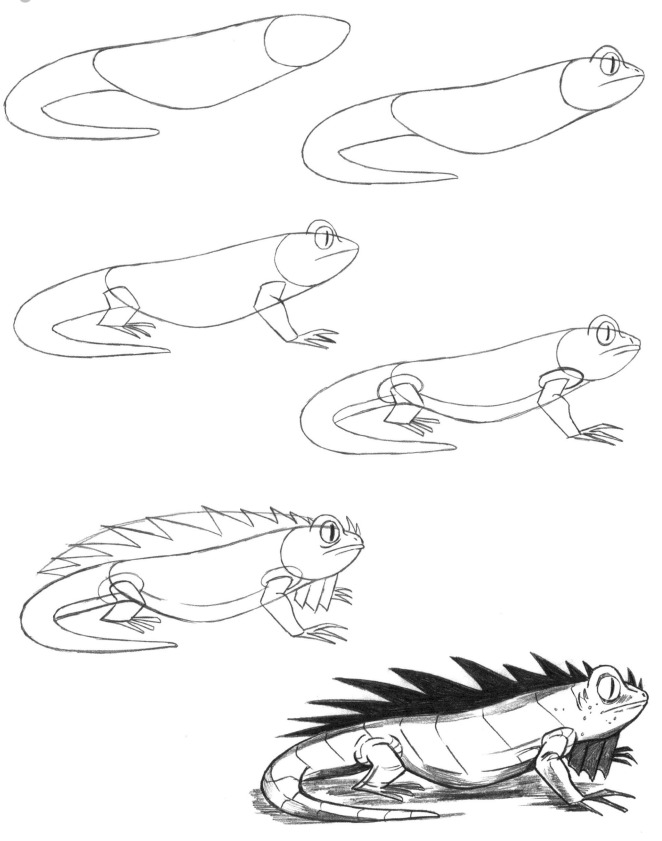

BEARS

Everyone loves bear cubs and bears. They have been the stars of TV shows, animated movies, and children's storybooks. Of course, real bears can be dangerous and powerful creatures; their teeth and claws make formidable weapons. But, admired from afar, they fascinate us with their expressive faces and huge, fuzzy girth. And, of course, bear cubs are adorable. Adult bears are also pretty comical, due to their big rump, which makes them bottom heavy. The legs are usually bent when standing or walking, and the torso hangs low to the ground. When drawing an adult bear's head, try to remember that the snout is long and thin, but the head is wide and round. Cubs have shorter snouts.

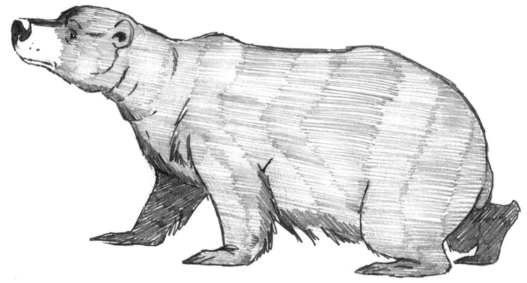

Expressive Bear

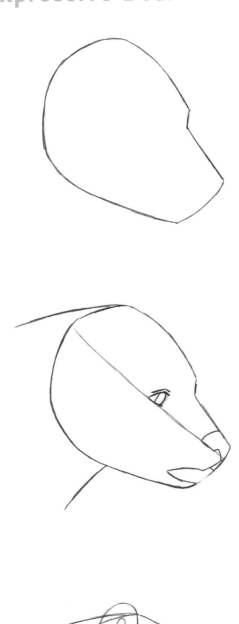

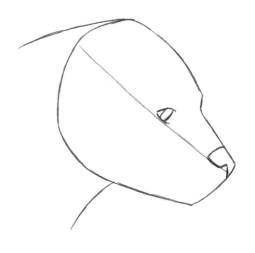

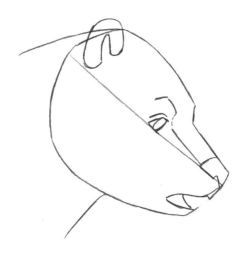

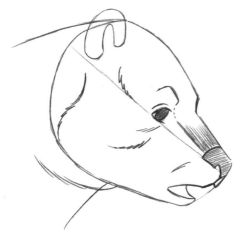

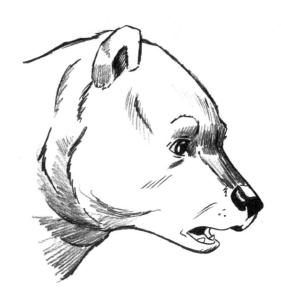

Resting Bear

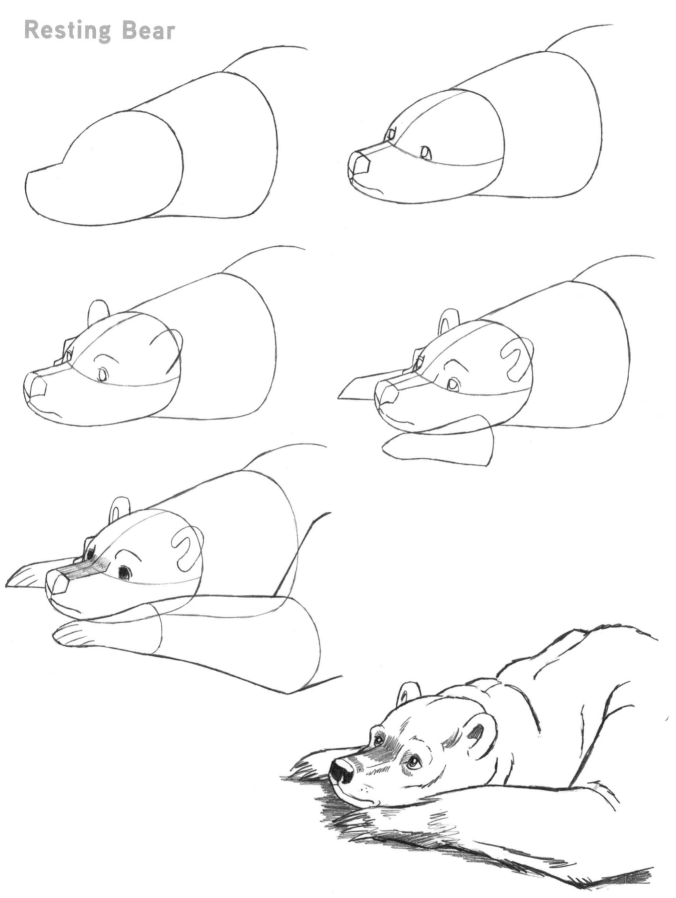

Curious Panda

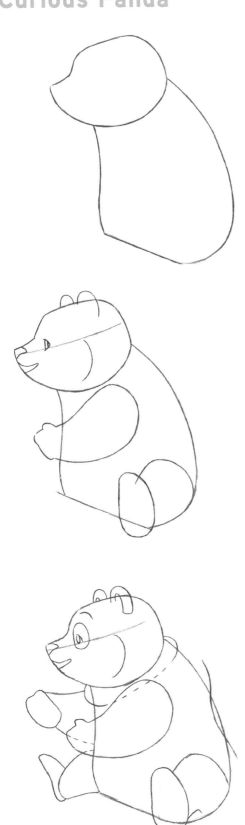

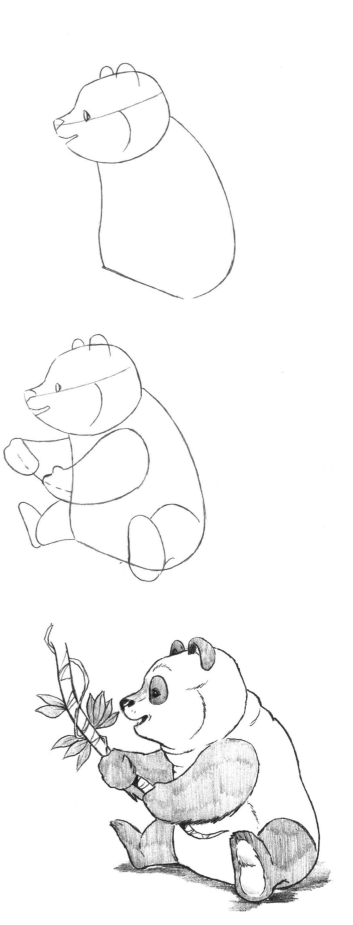

Walking Bear

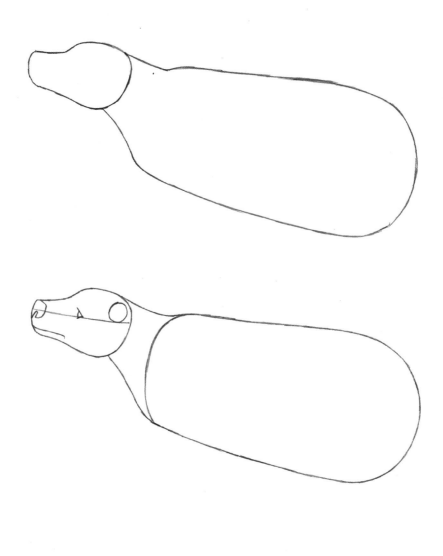

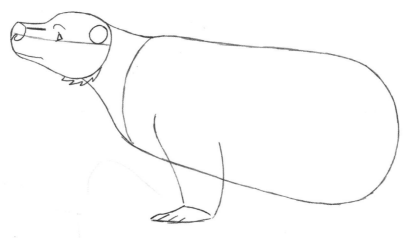

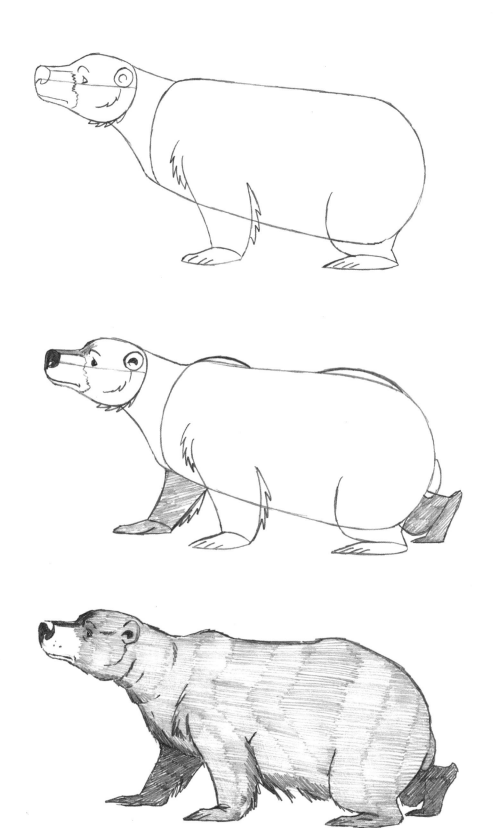

Standing Bear

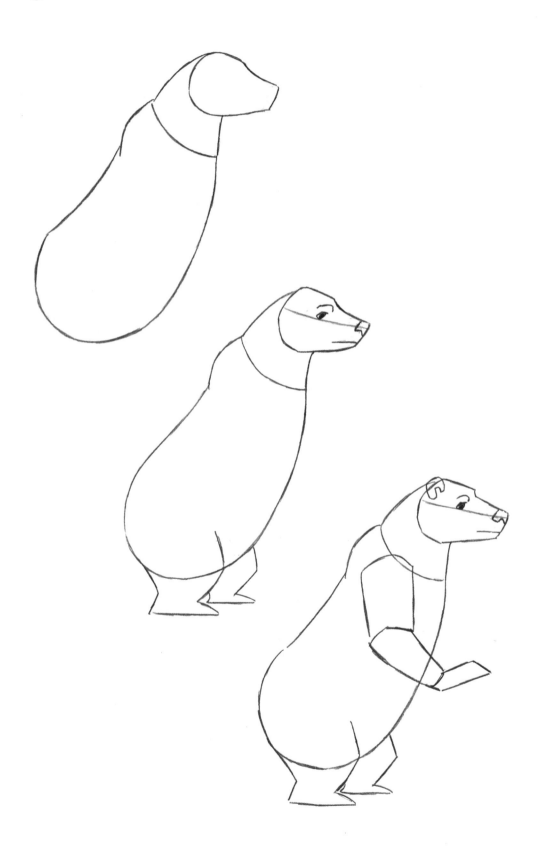

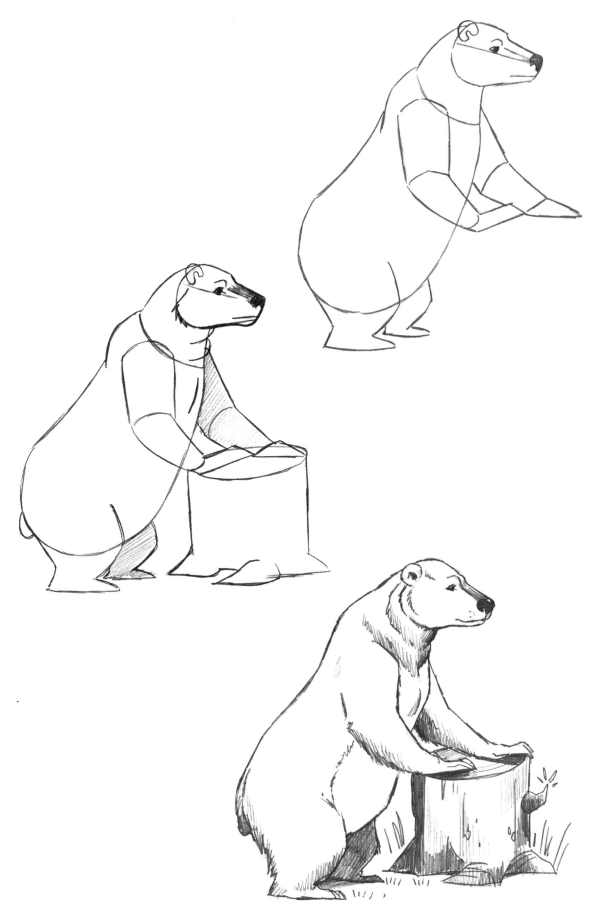

Hungry Bear

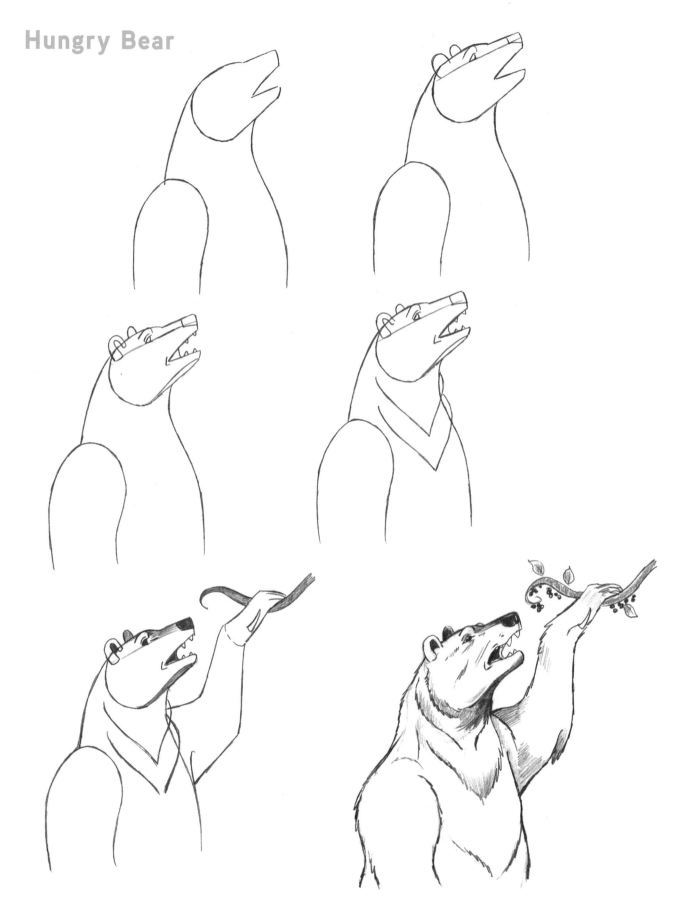

Bear Drinking

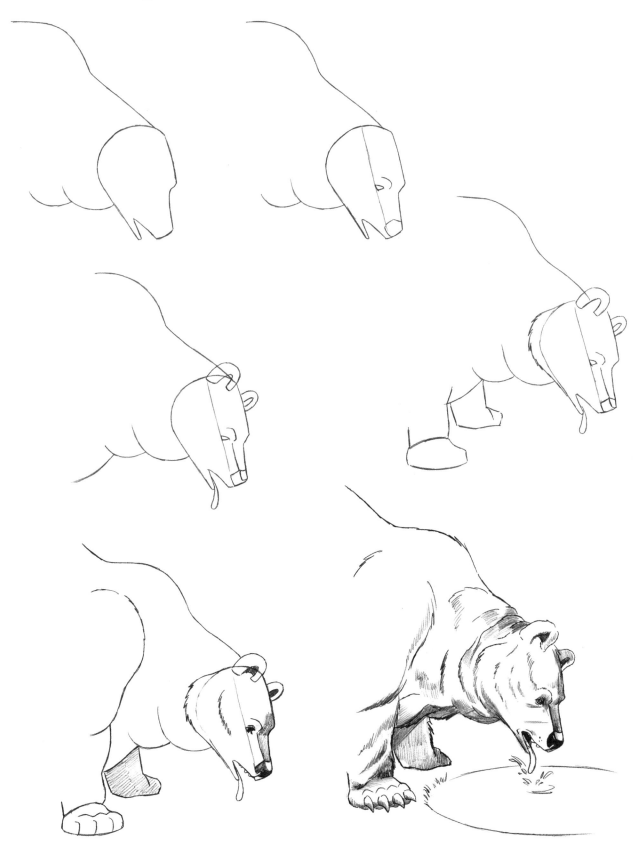

Adult Bear

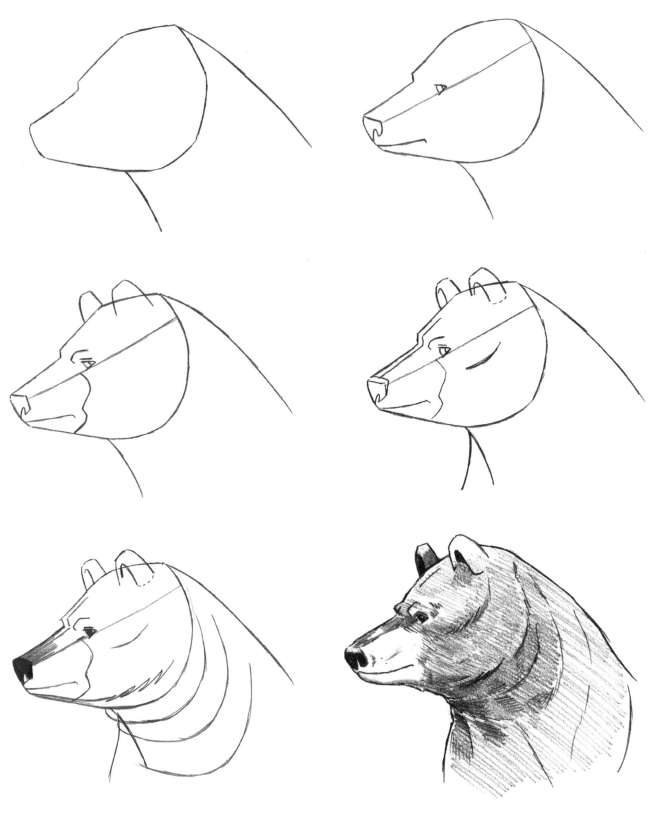

Bear Cub

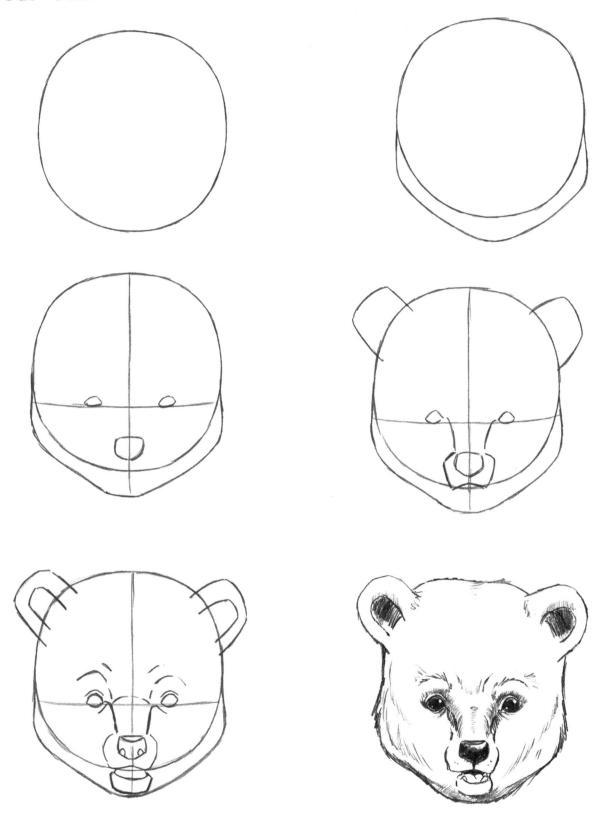

HORSES

Horses are among artists' favorite subjects to draw. It can be tricky, however, to figure out the angle of the legs and the lengths of the joints. But these easy-to-follow steps will guide you down the correct path to drawing a horse convincingly. Here's an important hint: Don't draw the back and tummy with straight lines, or the torso will look like a box. Instead, add a slight downward slope to the back, allow the tummy to sag just a touch, and let the chest protrude. And notice that the hooves are all drawn on a diagonal—and never horizontally. That's an important tip for making your horses look accurate and realistic.

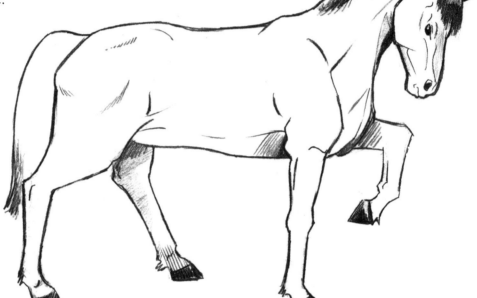

Horse's Head, Left Side View

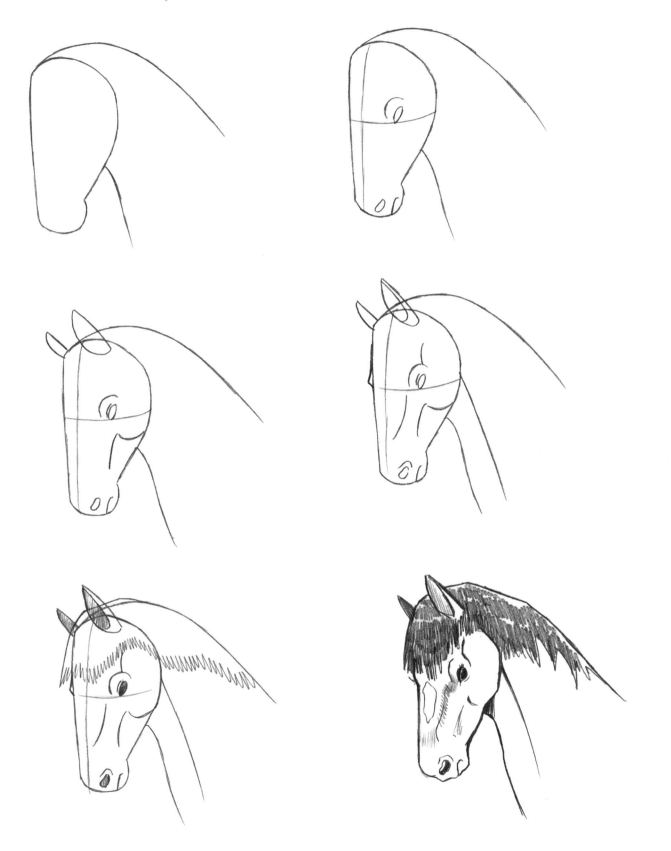

Horse's Head, Front View

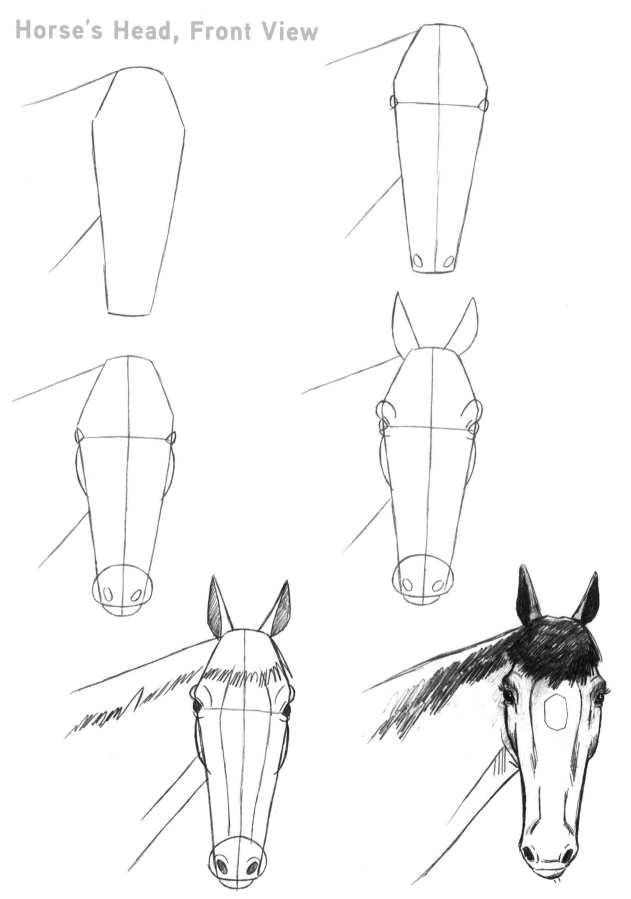

Horse's Head, Right Side View

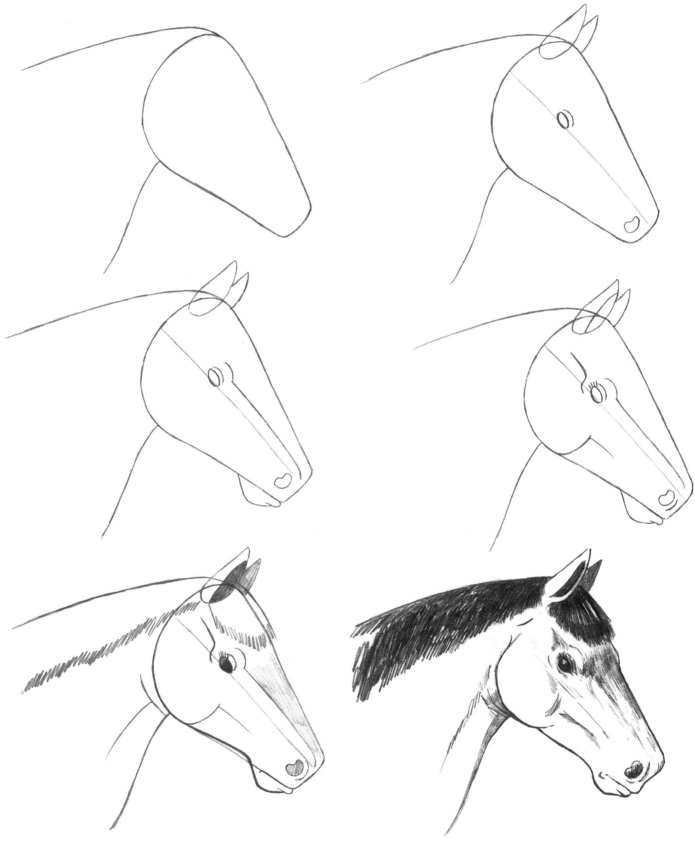

Horse with Front Leg Raised

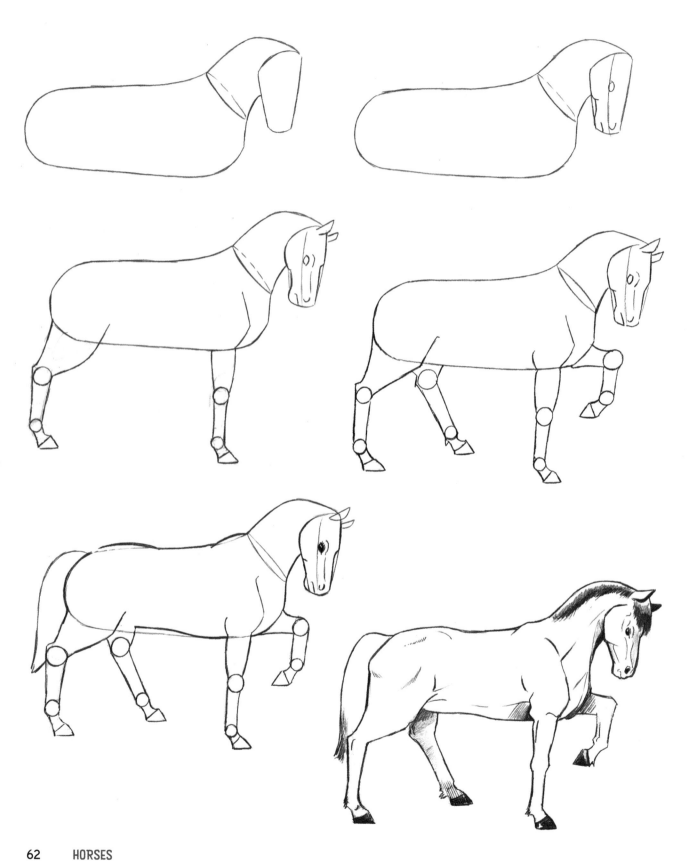

Horse Grazing

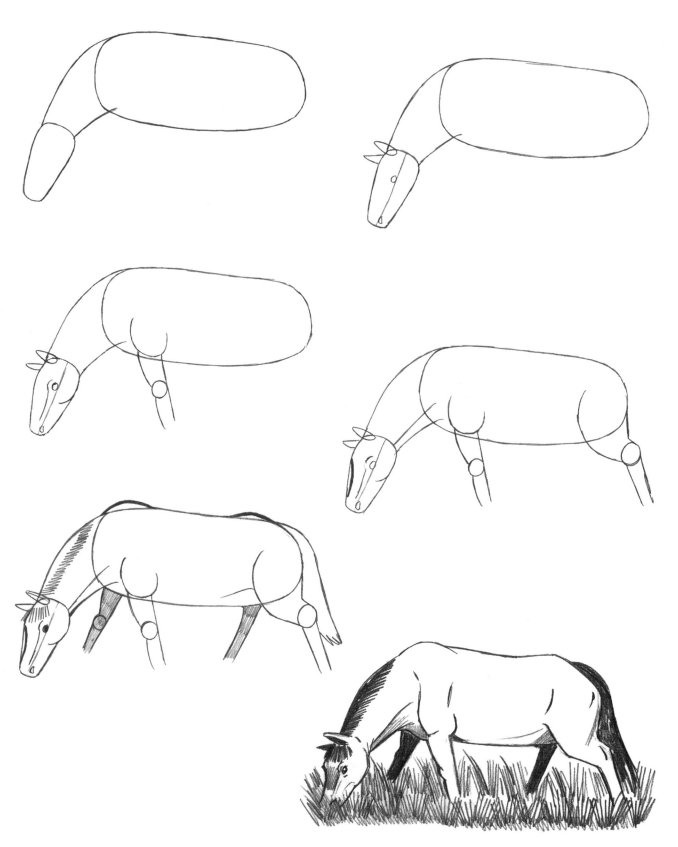

Horse Walking

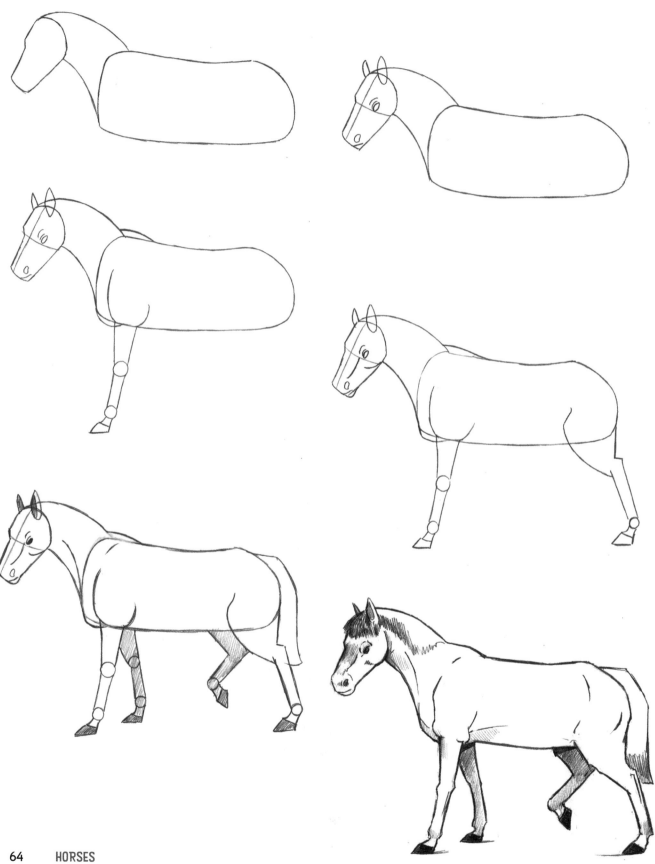

Horse Rearing Up

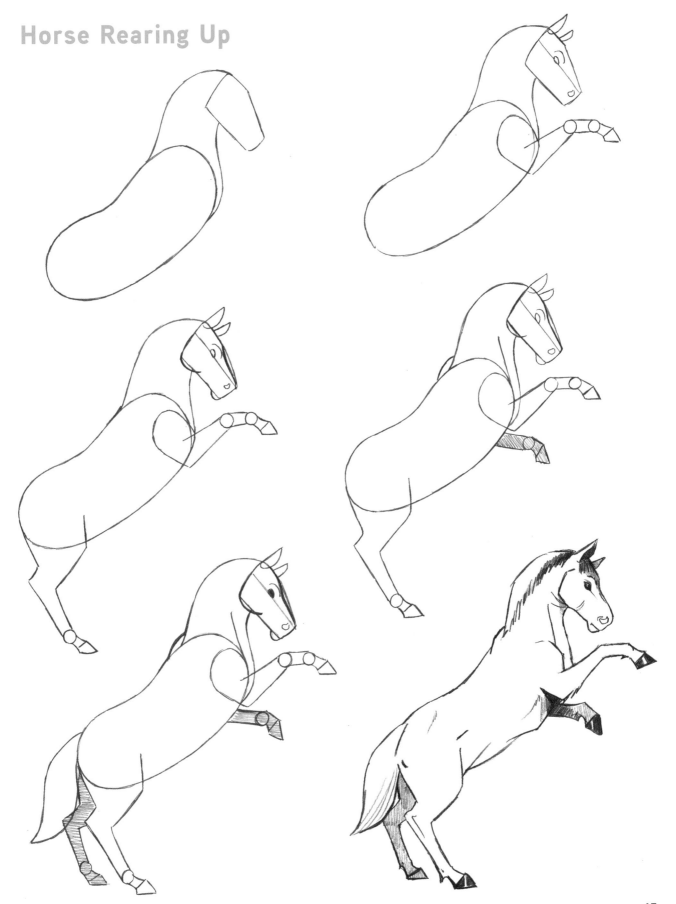

Horse Drinking

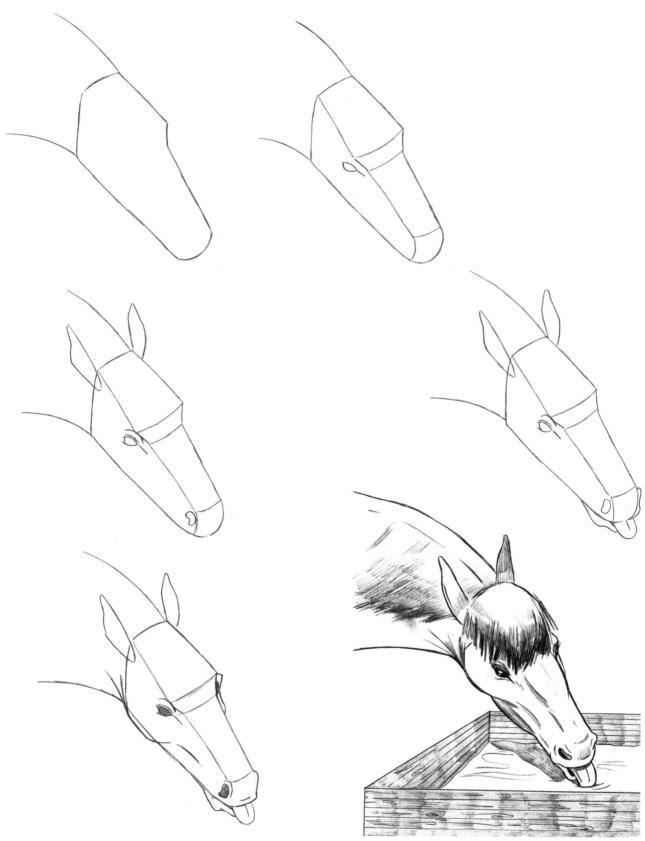

DOGS AND PUPPiES

Here's the section you've probably been waiting for: some of our favorite pets. We'll start with the dog. The great thing about dogs is that they are so expressive; no other animal seems to be able to convey emotions as clearly as a dog. But dogs can vary widely in appearance, depending on their breed. Therefore, we'll examine specific types of dogs individually to capture the particular features of each. Here are a couple of hints for avoiding common mistakes: Make sure the neck is long enough and that the head angles slightly downward in an ordinary, standing pose. Most dogs have slightly bigger chests than tummies—unless you've overfed them! The tail extends from the spine as a single, flowing line. The forehead is always low, and the chin is very small. The paws are also small, unless the dog is a pup, in which case the paws and ears should be oversized. I'm sure you'll recognize some of these popular traits and famous breeds as you tackle these next few pages.

Labrador Retriever

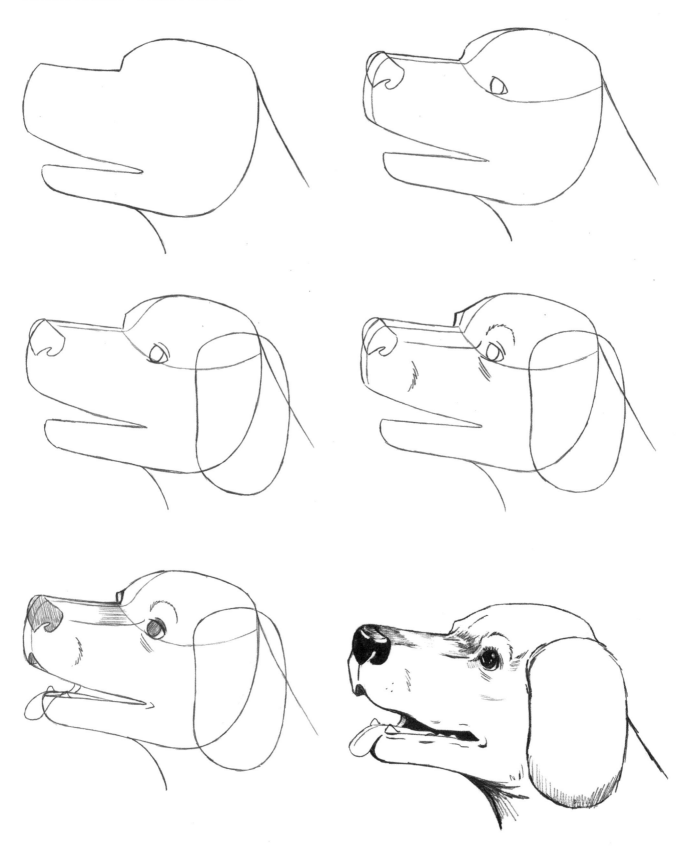

Dalmatian Begging

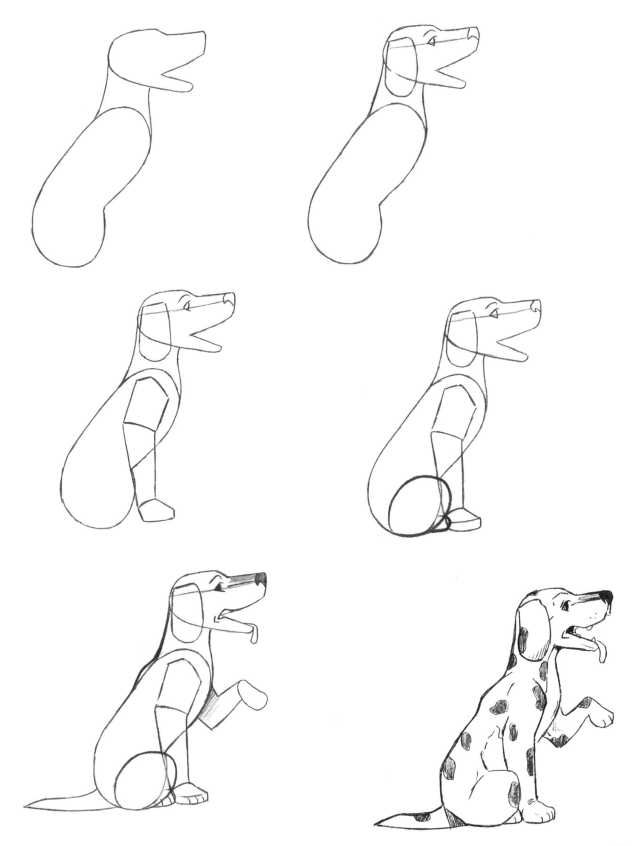

Dalmatian Sitting

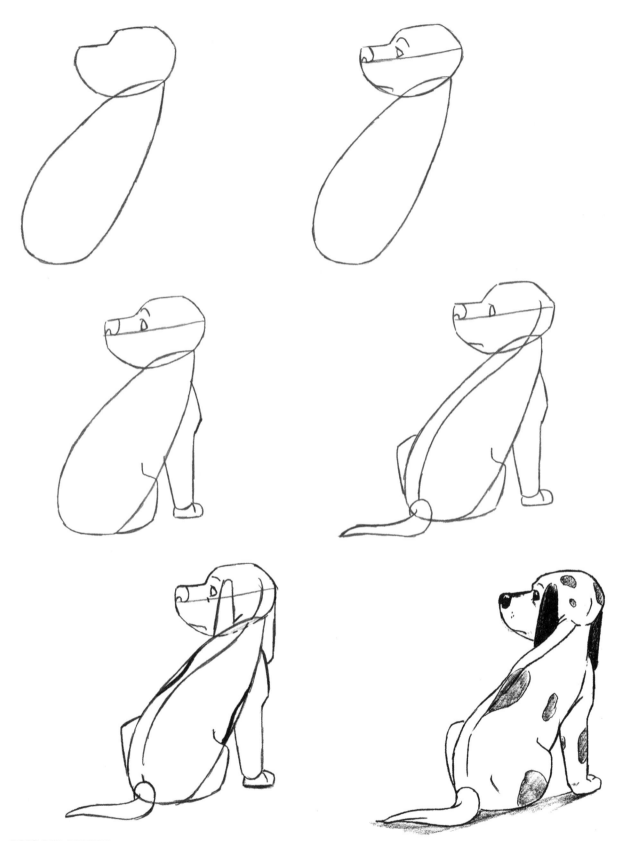

Toy Poodle

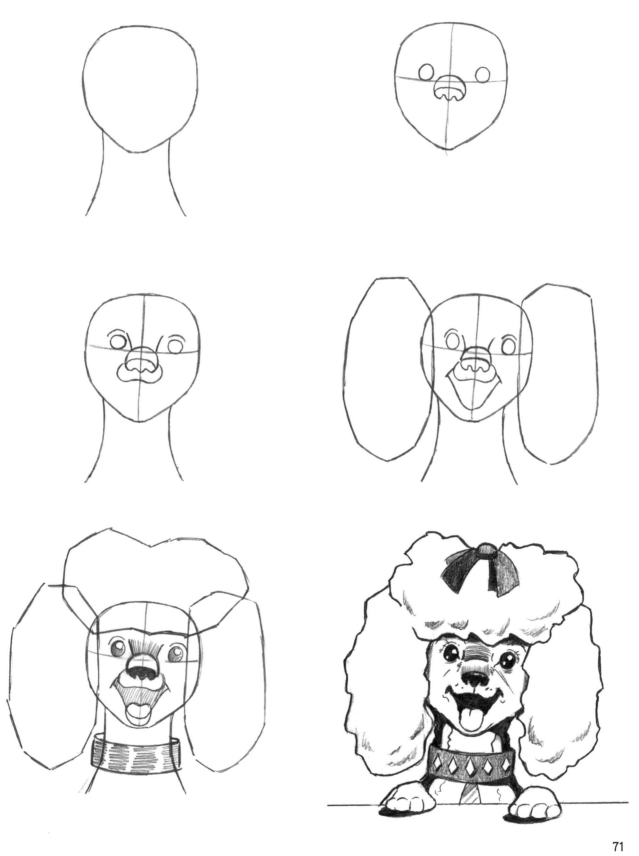

Weimaraner

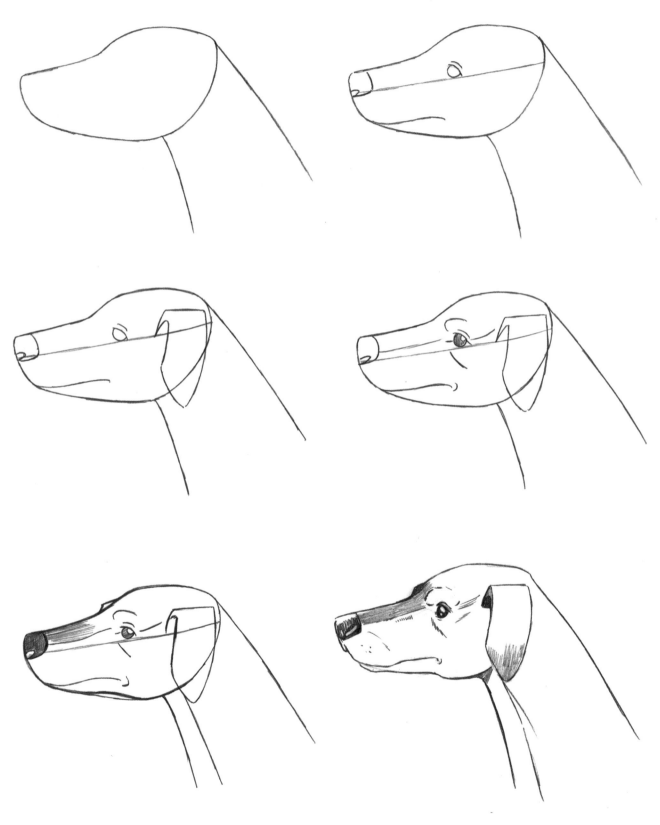

Weimaraner Resting

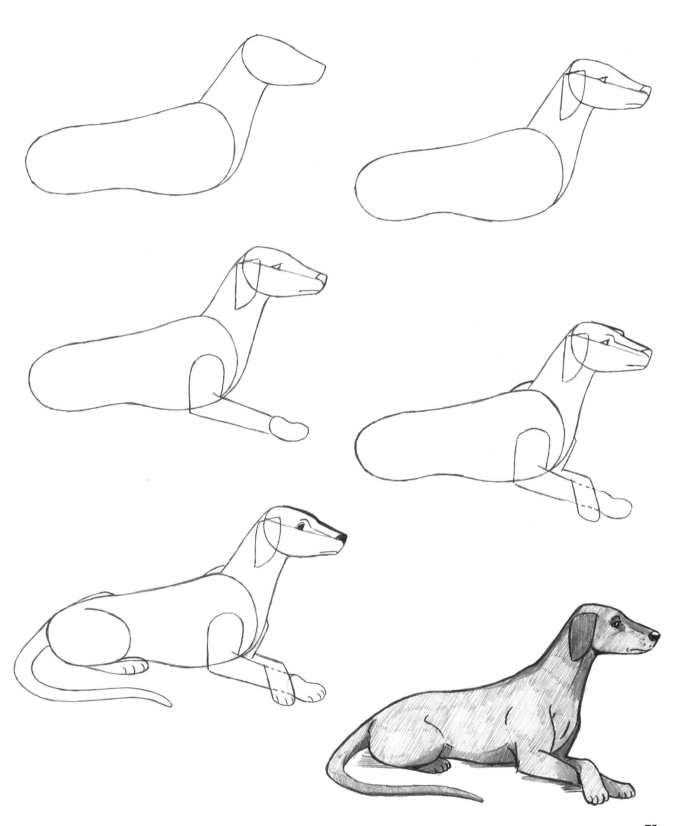

Westie

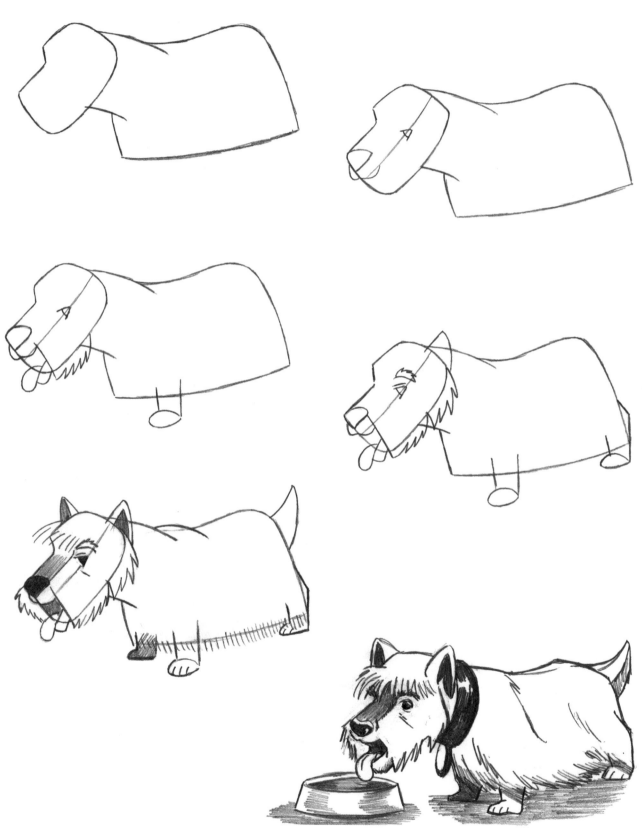

Harrier

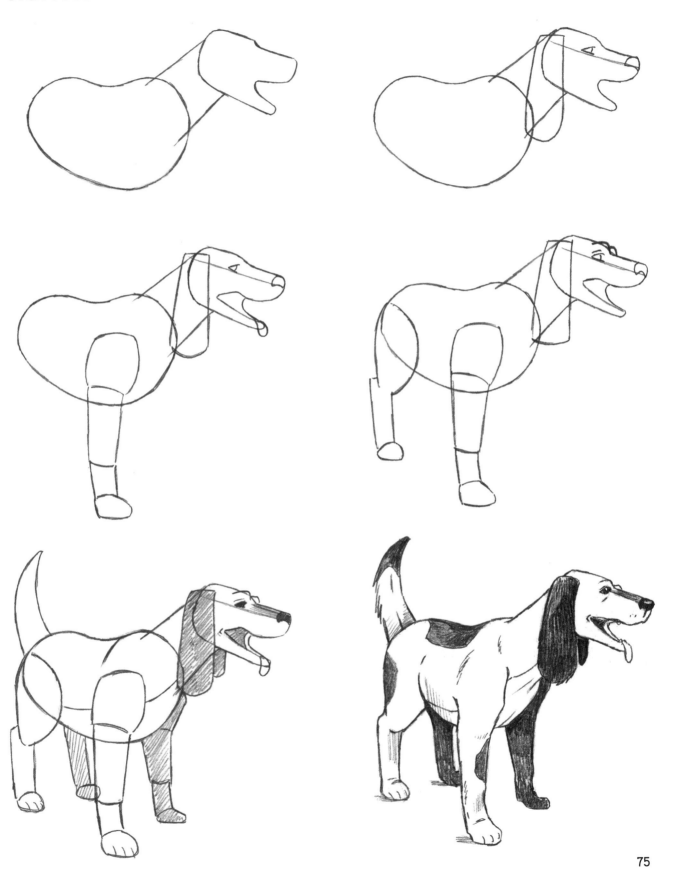

My Dog, Mickey (Mixed Breed)

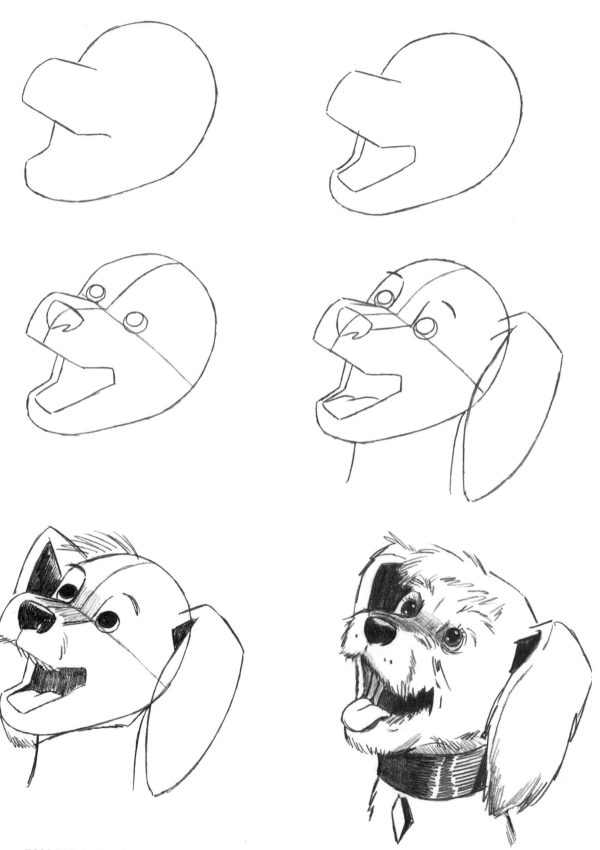

Beagle

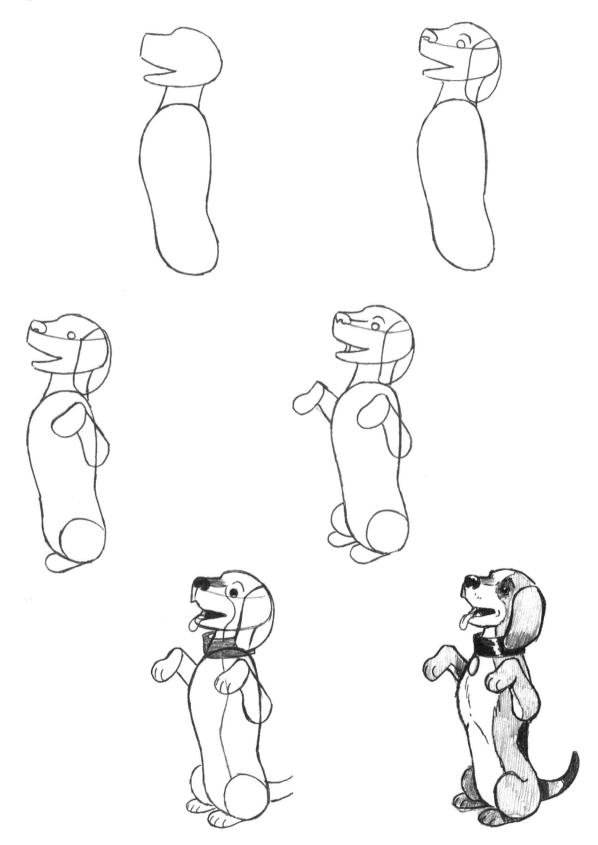

Dog Retrieving

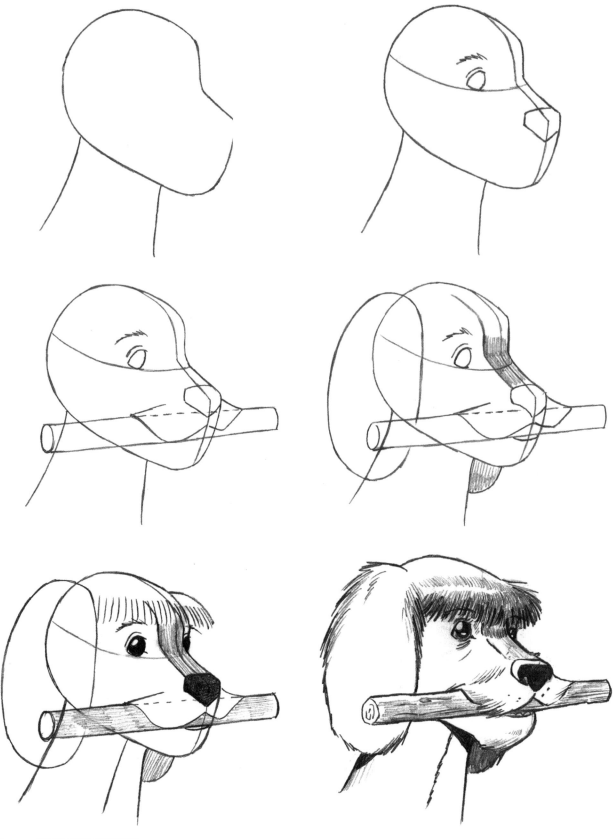

Dog Following a Scent

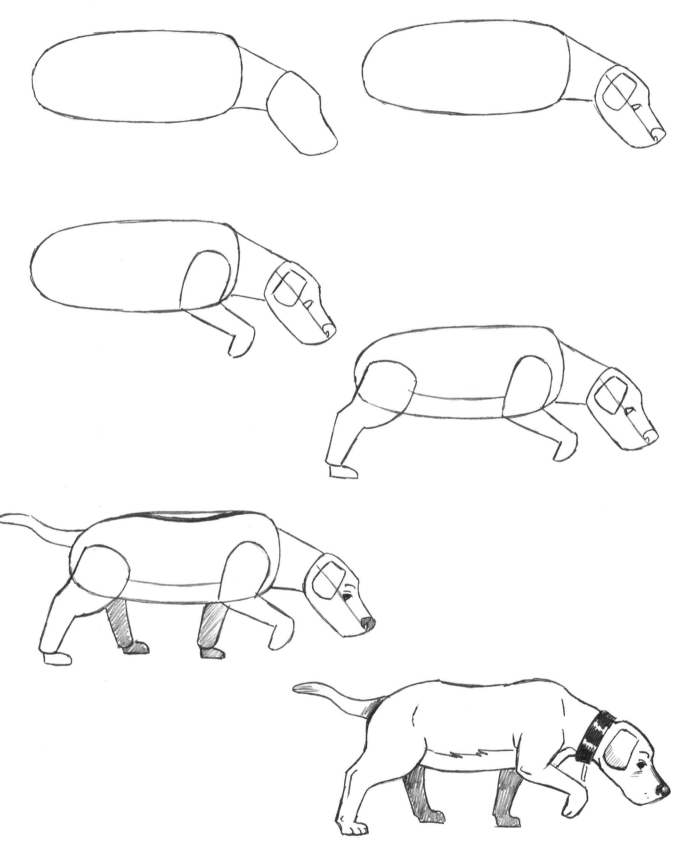

Doggy Slumber

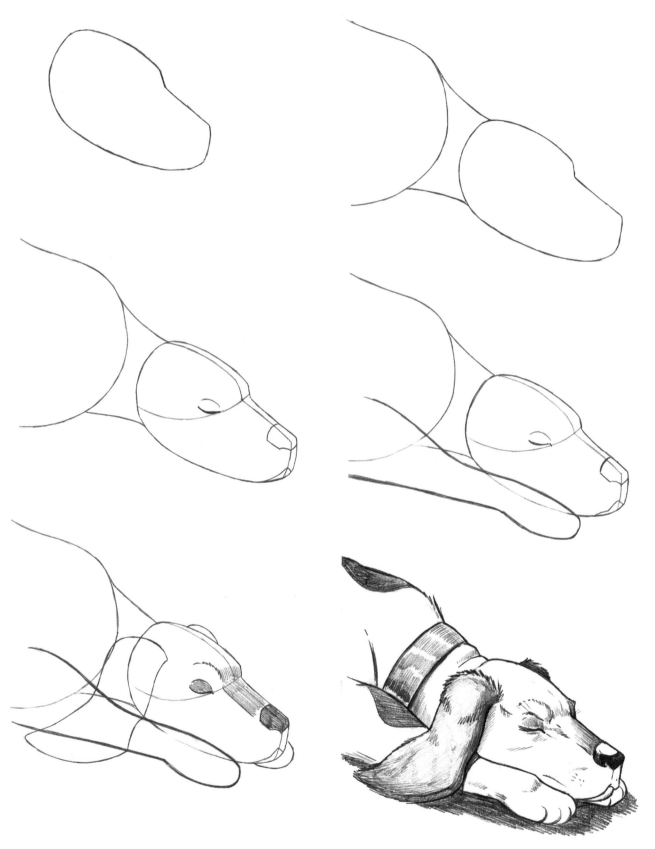

CATS AND KiTTENS

People who love cats can find endless amusement in watching them. Cats can act aloof, needy, curious, naughty, playful, or extremely single-minded—which almost sounds like a human being. Sometimes, newer artists overlook a few basic principles when drawing cats, because their bodies are often covered by a lot of fur—the cats' bodies, I mean. But all cats have certain basic features in common that are important for an artist to note. For example, cats have very short muzzles, but their eyes are quite big for the size of their head, which gives them a cute look. The chest is slightly smaller than the tummy, and the back curves just a little bit. The legs, especially the hind ones, are usually bent, even when standing in a relaxed pose. A cat's neck is somewhat thick compared to its head, which is on the small side compared to the rest of their body. And their legs taper down to tiny, rounded paws. You can add markings to almost any type of cat to make it look like a different breed. This technique doesn't always work on dogs. For example, you wouldn't put a dalmatian's spots on a Westie.

Cat at Play

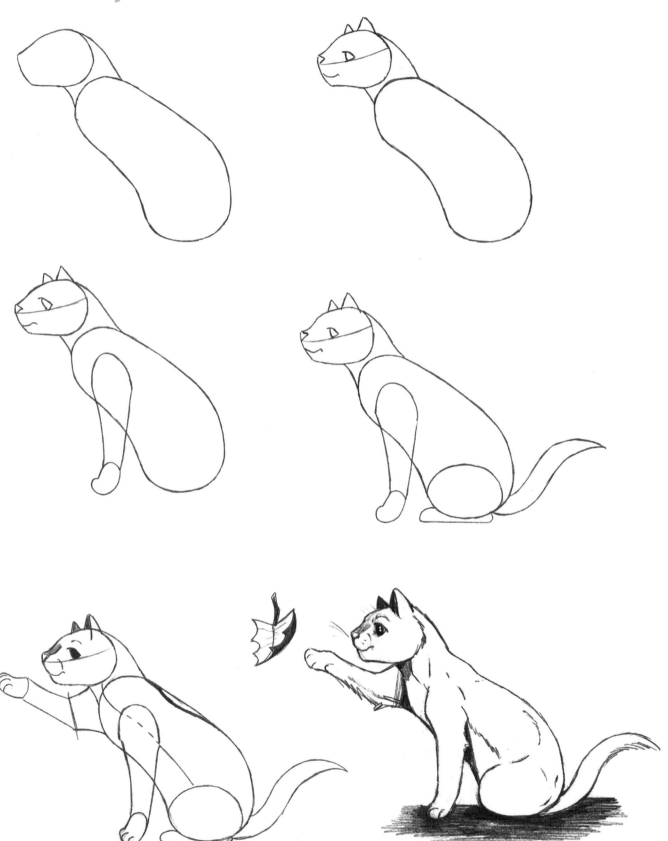

Cat Leaping

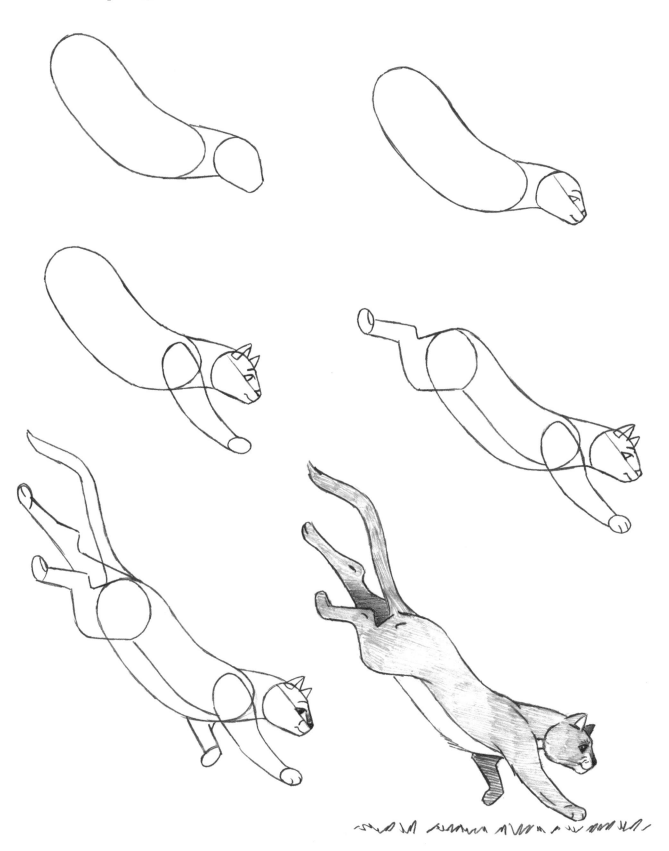

Kitten's Balancing Act

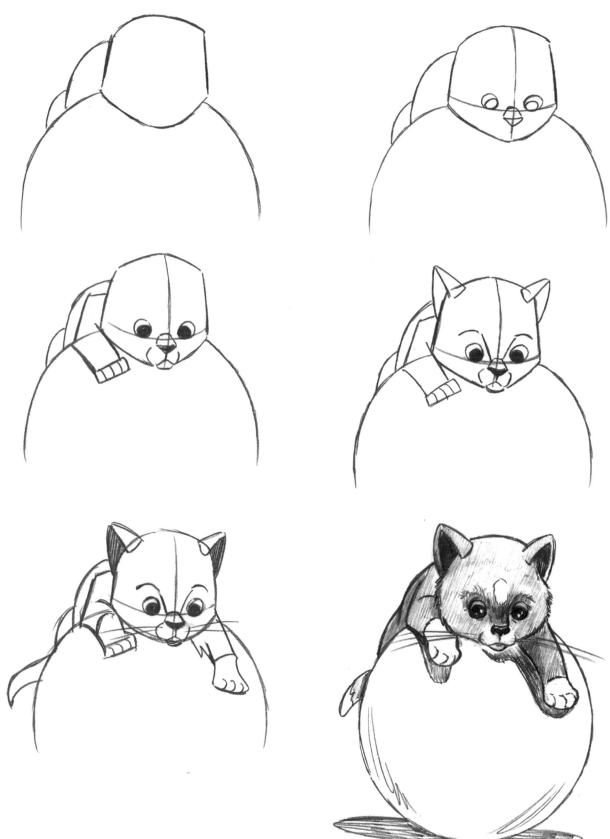

Cat Gazing

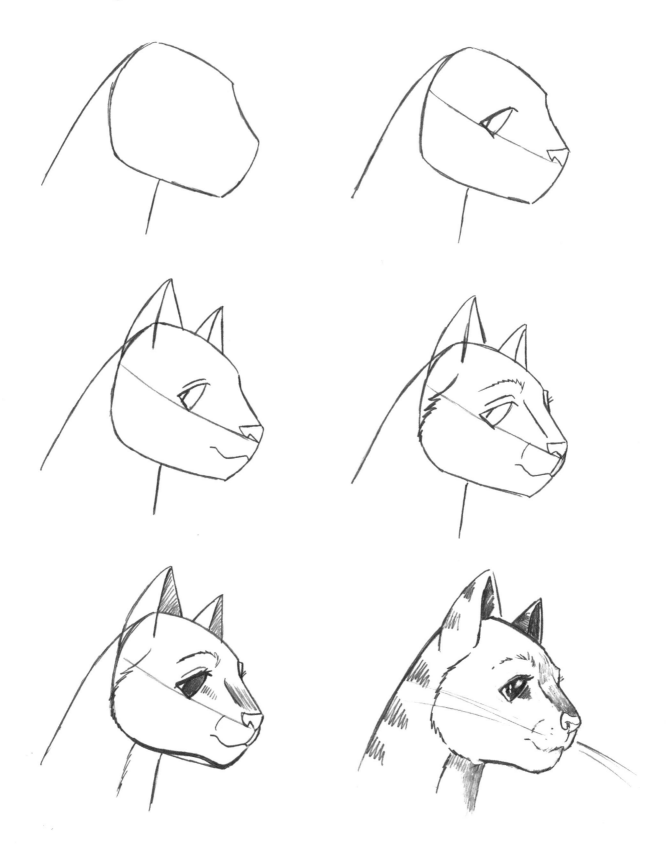

Yummy Meal

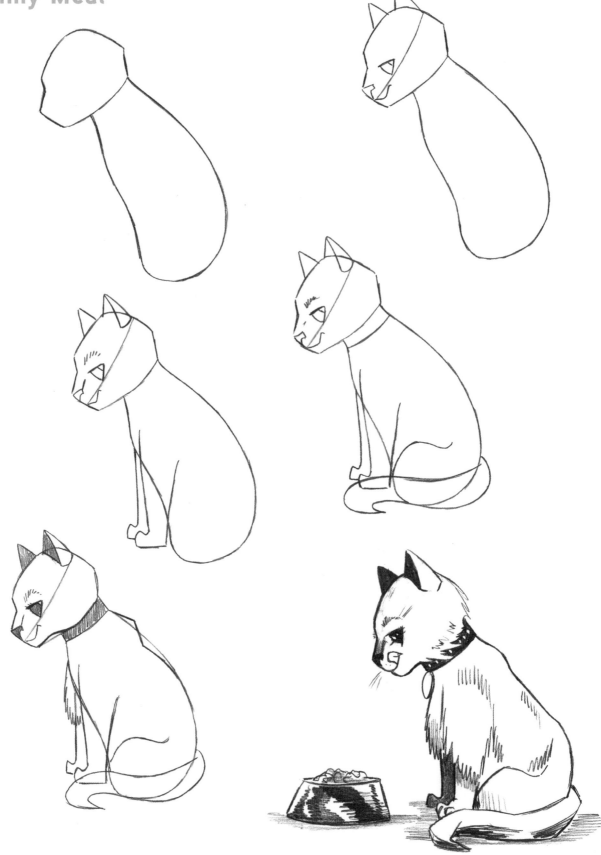

Cat Playing

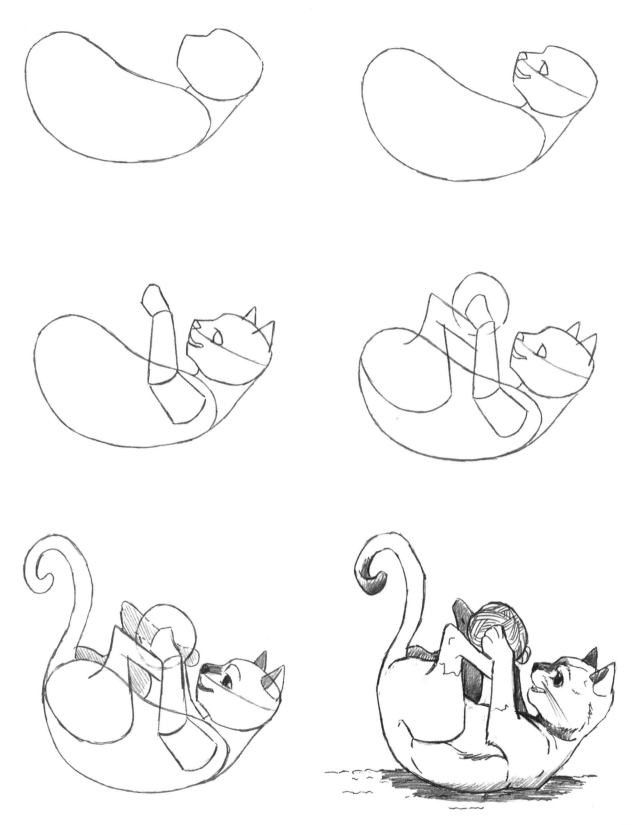

Cat Cleaning Itself

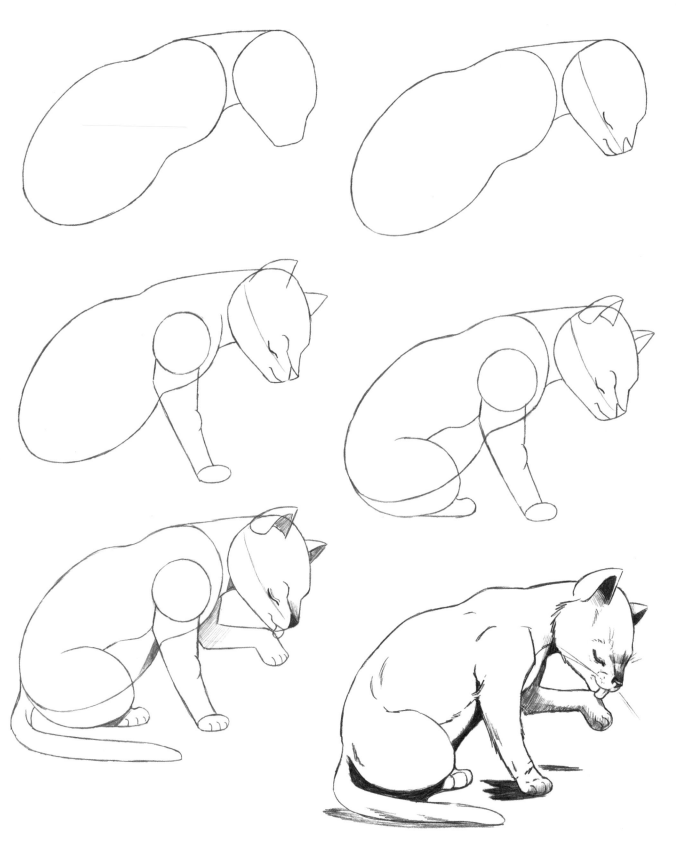

Cat Nap

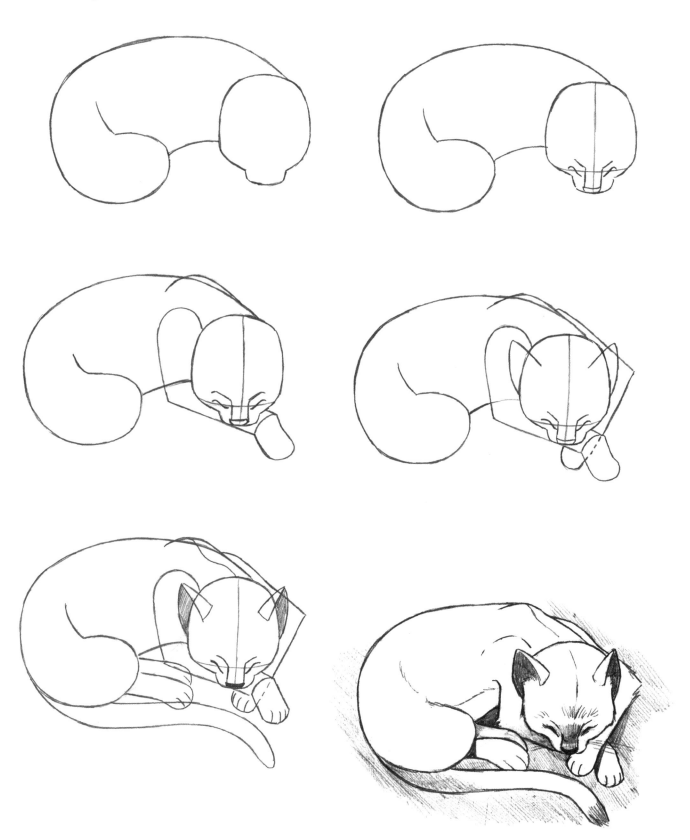

Balancing Act

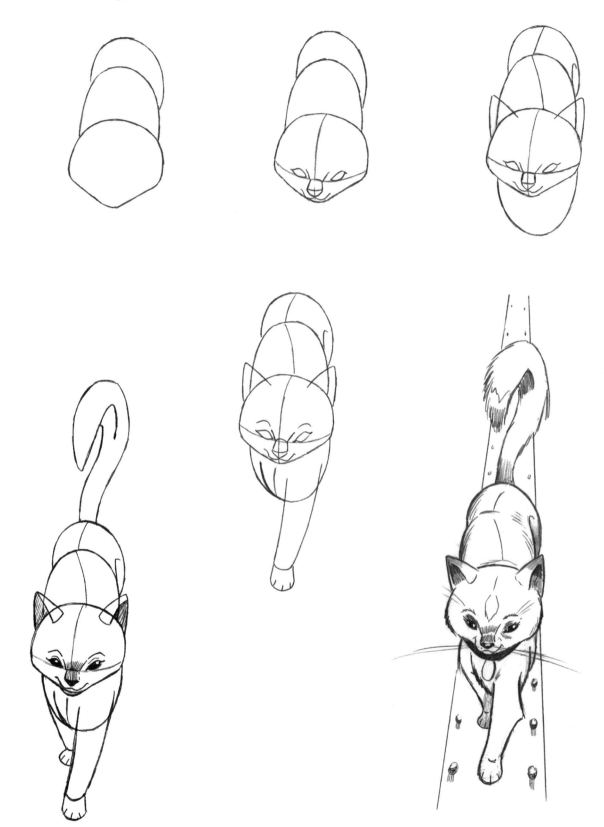

Cat Stalking

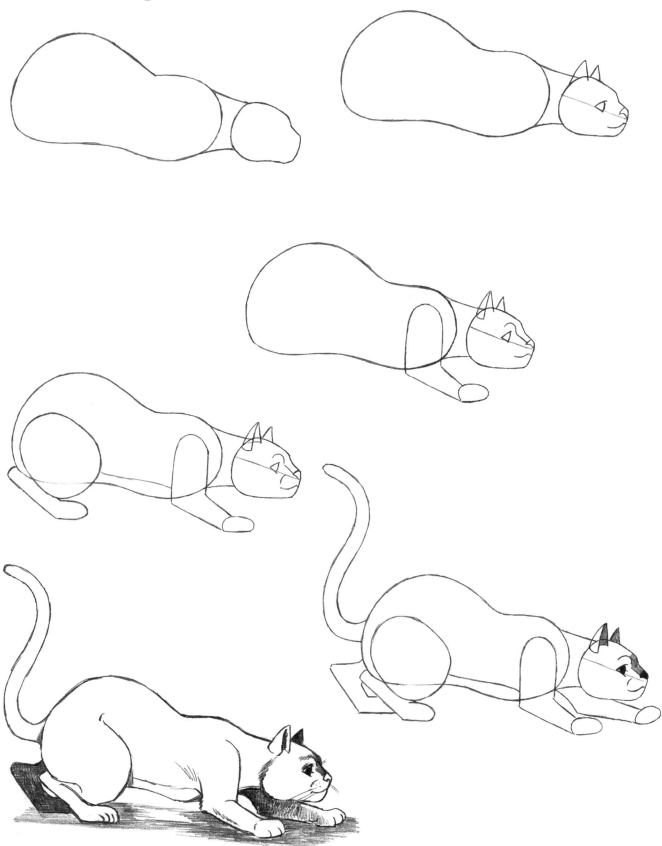

Kitty Caught Off Guard

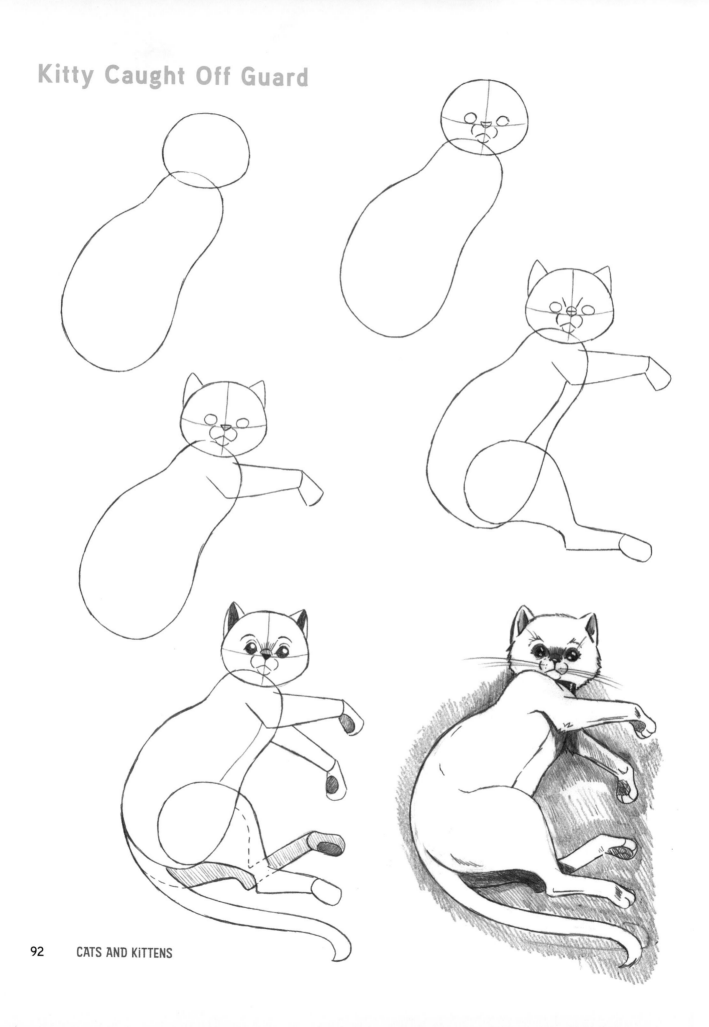

CATS AND KITTENS

ANiMALS OF AFRiCA

Africa is home to some of the biggest and tallest land creatures in the entire animal kingdom. You already know the prominent features of these animals, such as the trunk on an elephant, the neck on a giraffe, or the horns on a rhino. But the subtler features of these animals are equally important. For example, do you know where the tusks start on an elephant or how to draw the deep slope of the rhino's forehead? These step-by-step demonstrations will show you all the tricks you need to draw each animal in this section realistically. You'll be amazed at how much more lifelike they become once you know how to incorporate these important touches.

Hippo

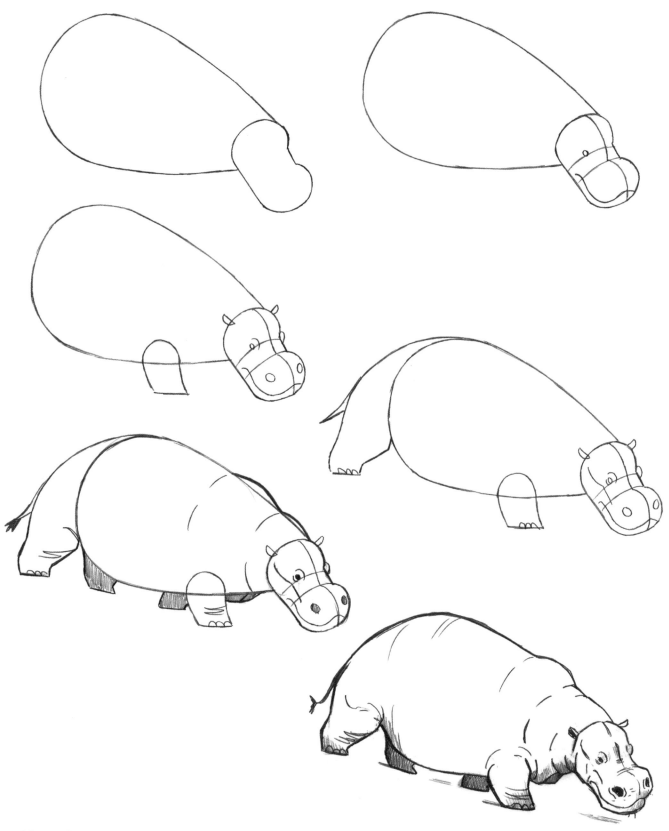

Hippo in Water

Gazelle

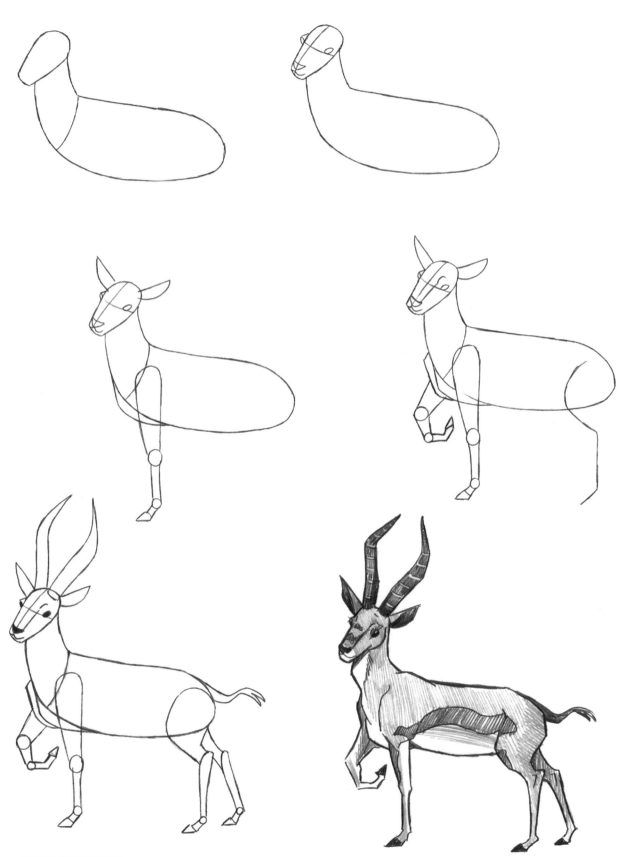

Elephant Face

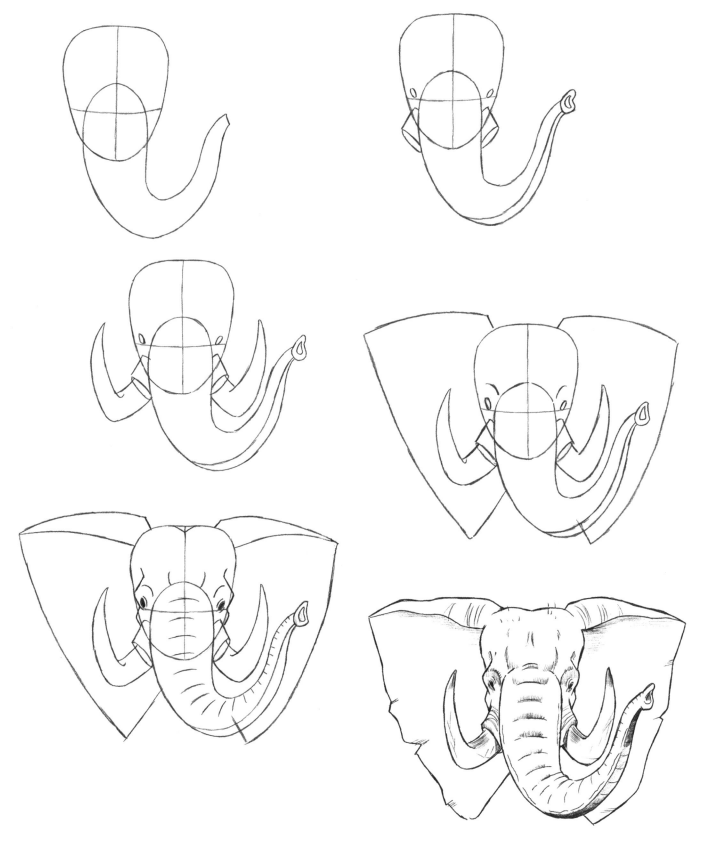

Elephant Walking

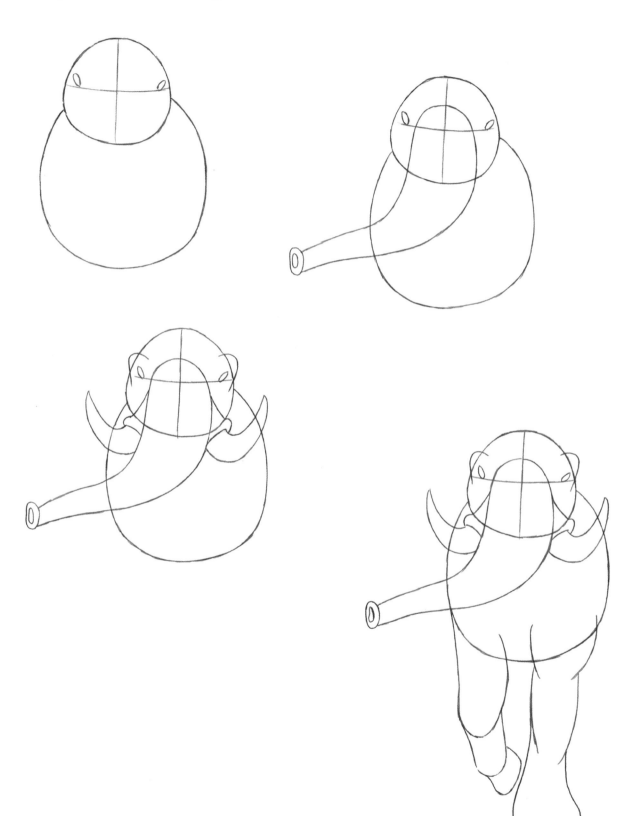

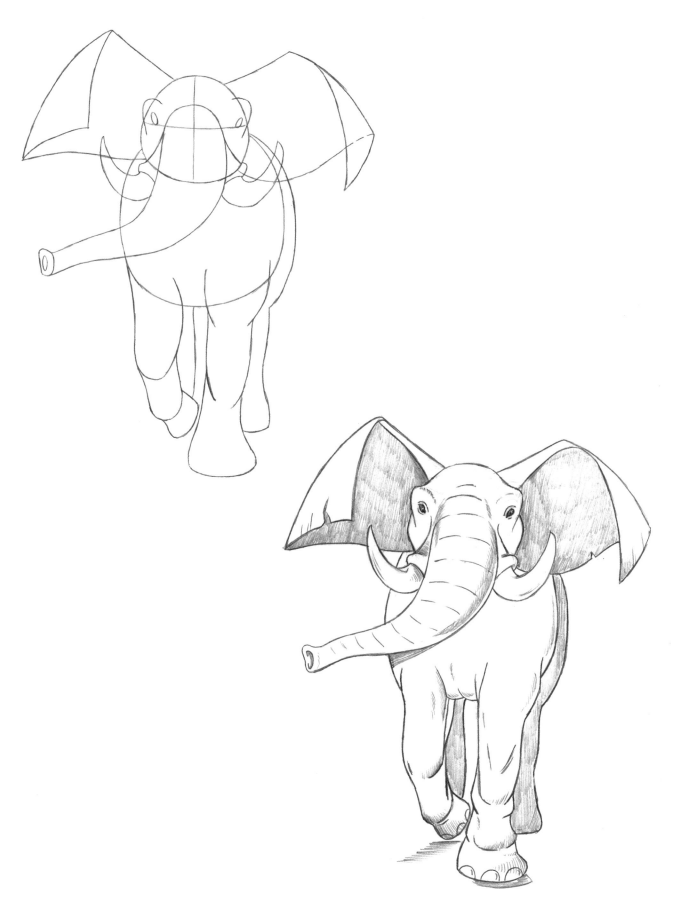

Elephant Drinking

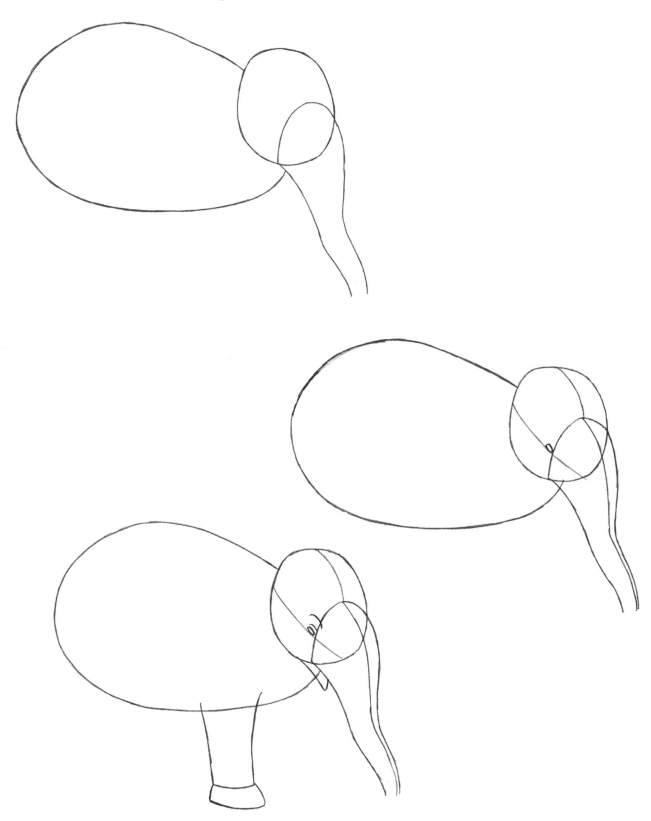

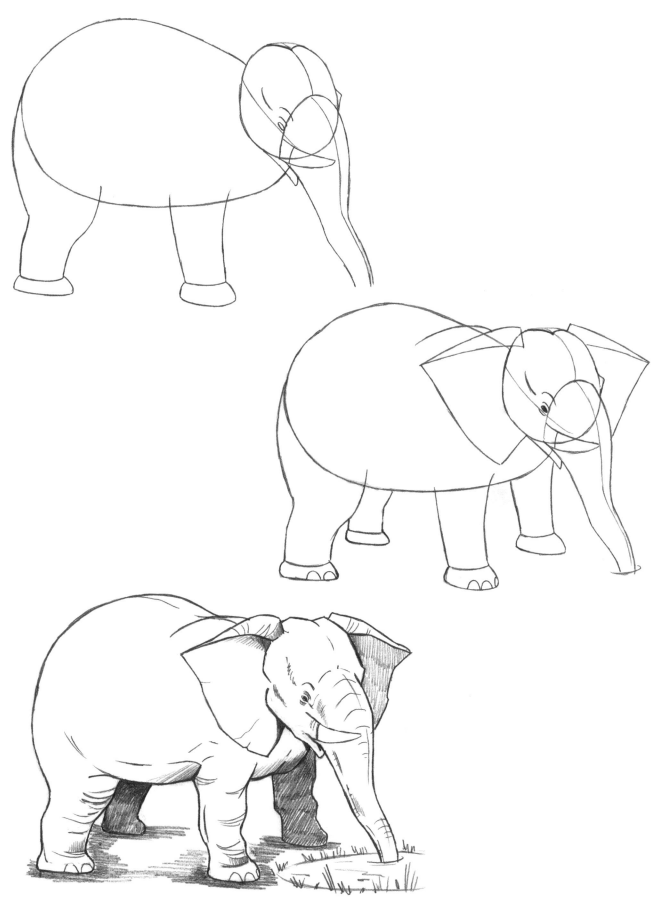

Baby Elephant

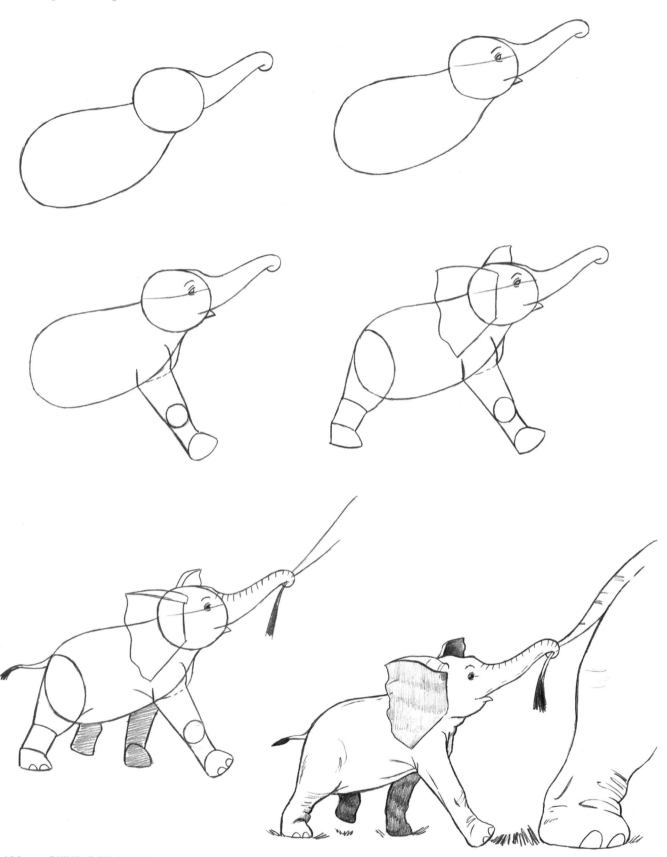

Giraffe Enjoying Lunch

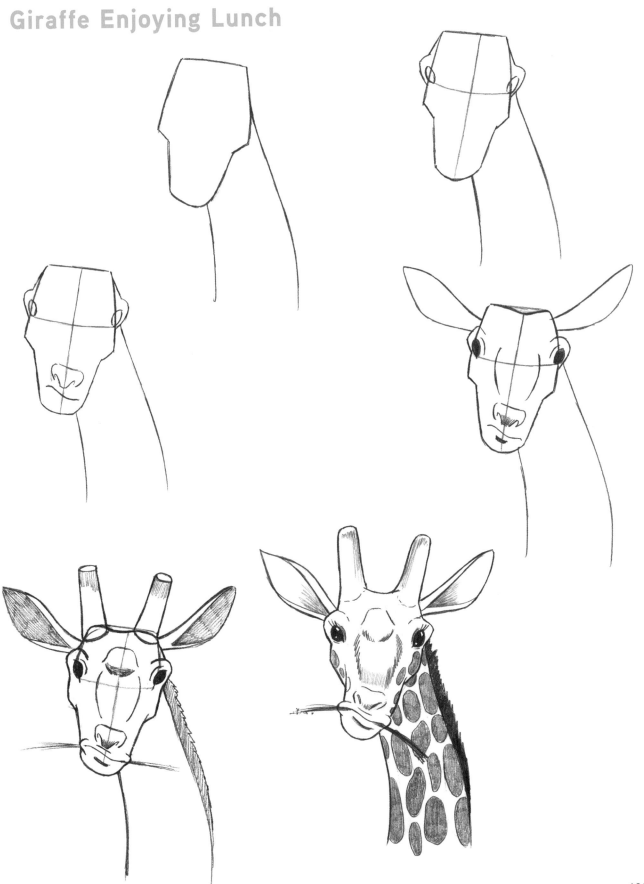

Standing Giraffe

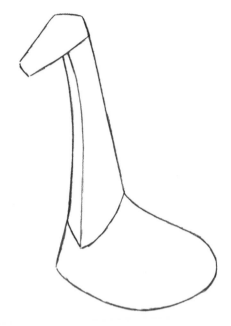

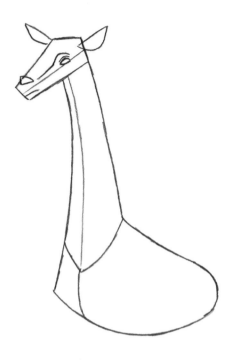

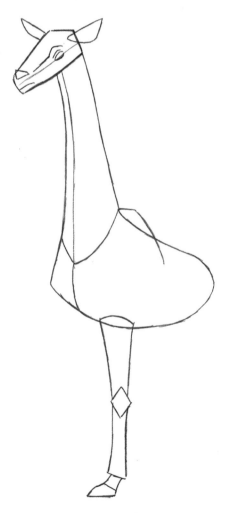

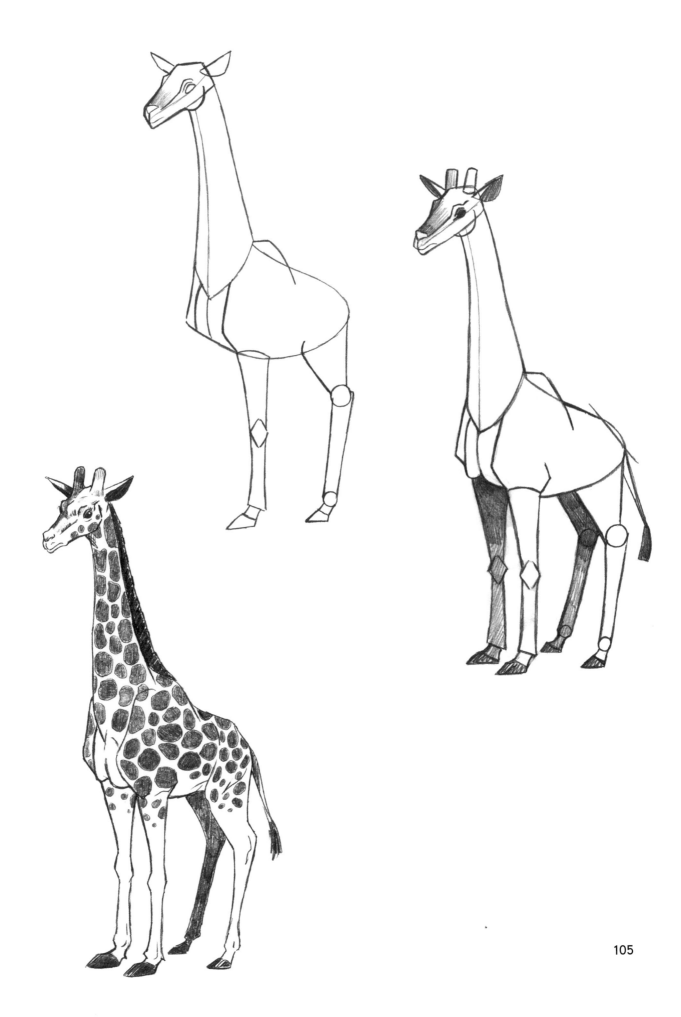

Rhinoceros

PREDATORS

Africa and Asia boast two of the world's greatest hunters: lions and tigers. These animals are bold yet majestic and beautiful. Their bodies are strong and sleek, which makes them fun subjects to draw. They both have small eyes and a large snout. These big cats have prominent chins and very low foreheads that slope gently into their snouts. Most people don't notice it, but since you're an artist, you'll observe that lions and tigers both have legs that are on the short side. However, their legs are thick and attached to bulky shoulder muscles. Their hind legs attach to narrow hips. This construction makes their physiques look powerful and agile. The tail always hovers close to the ground, unless the animal is excited or in a dynamic pose. Don't forget the mane or stripes!

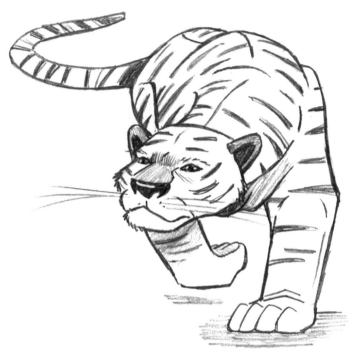

Lioness Stalking

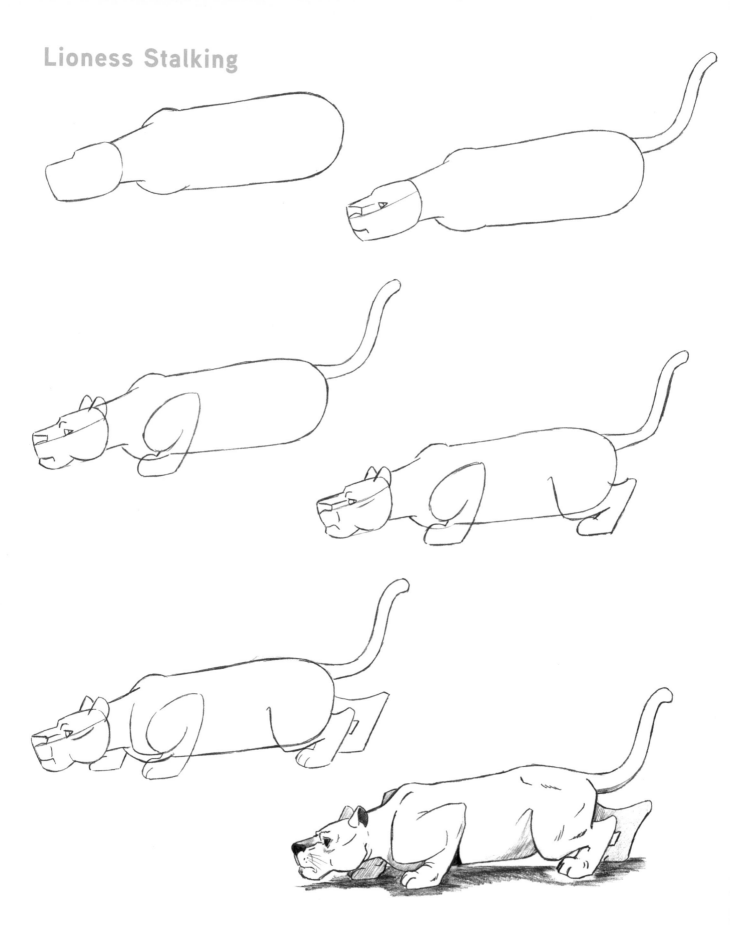

Surveying the Savanna

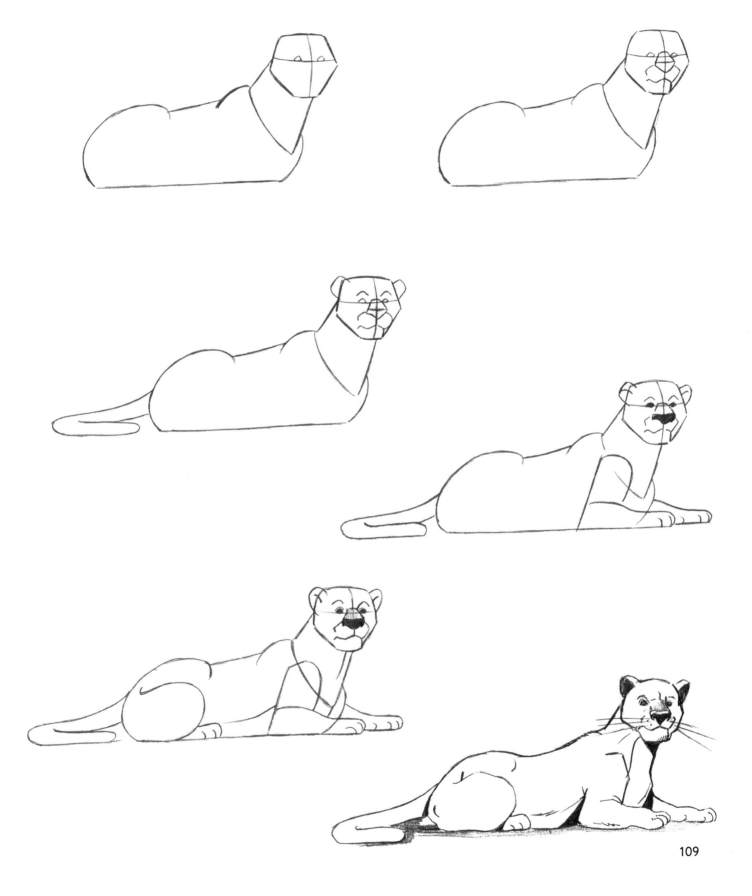

Male Lion, Front View

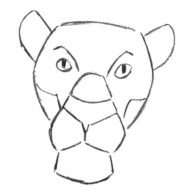

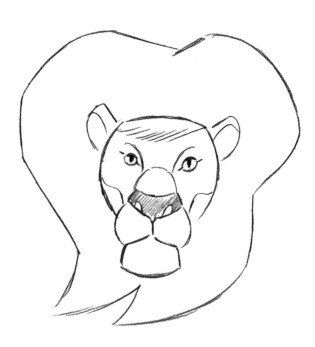

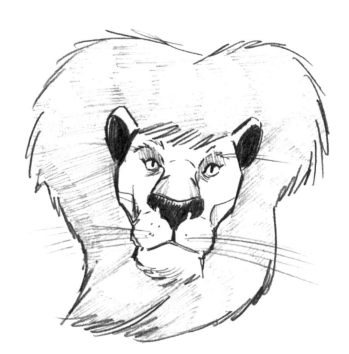

Male Lion, Side View

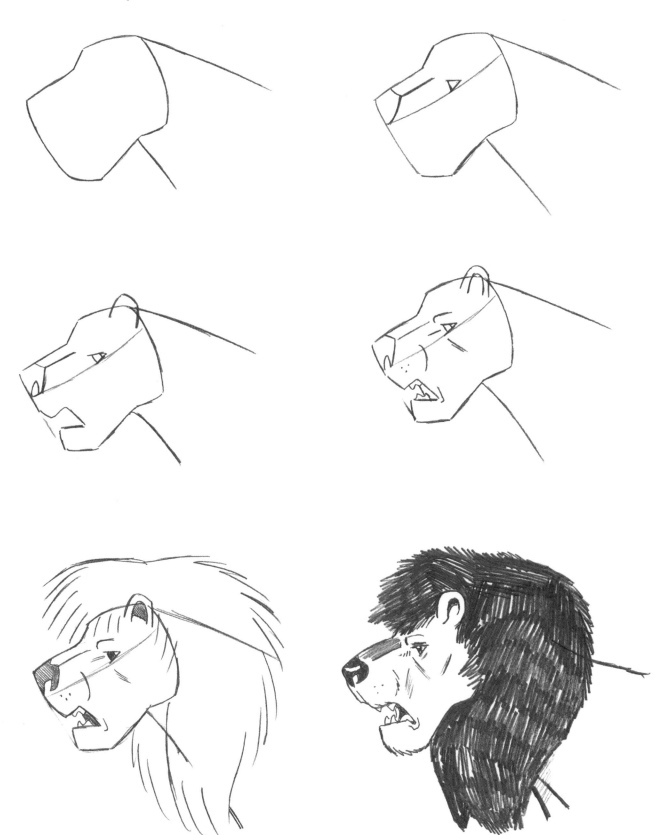

Tiger

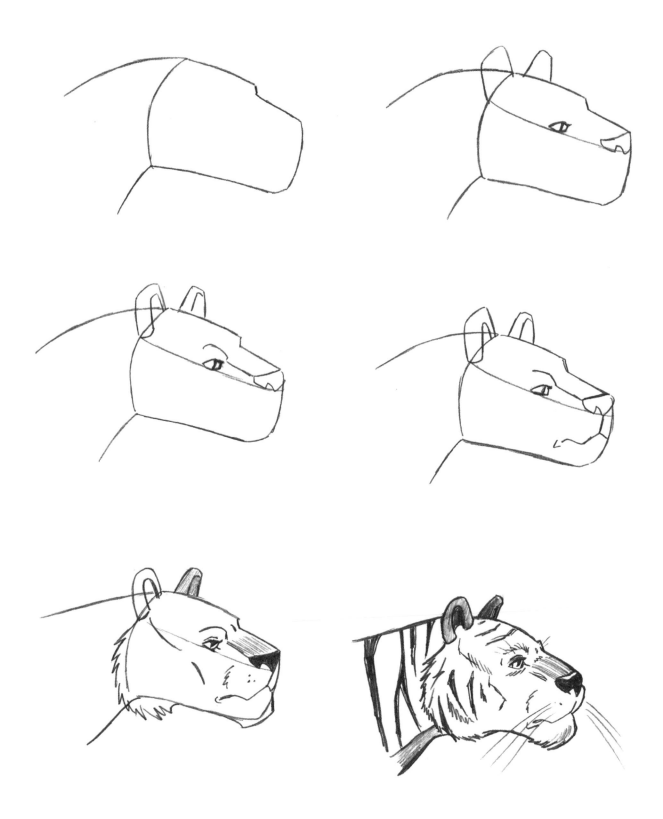

Tiger on the Prowl

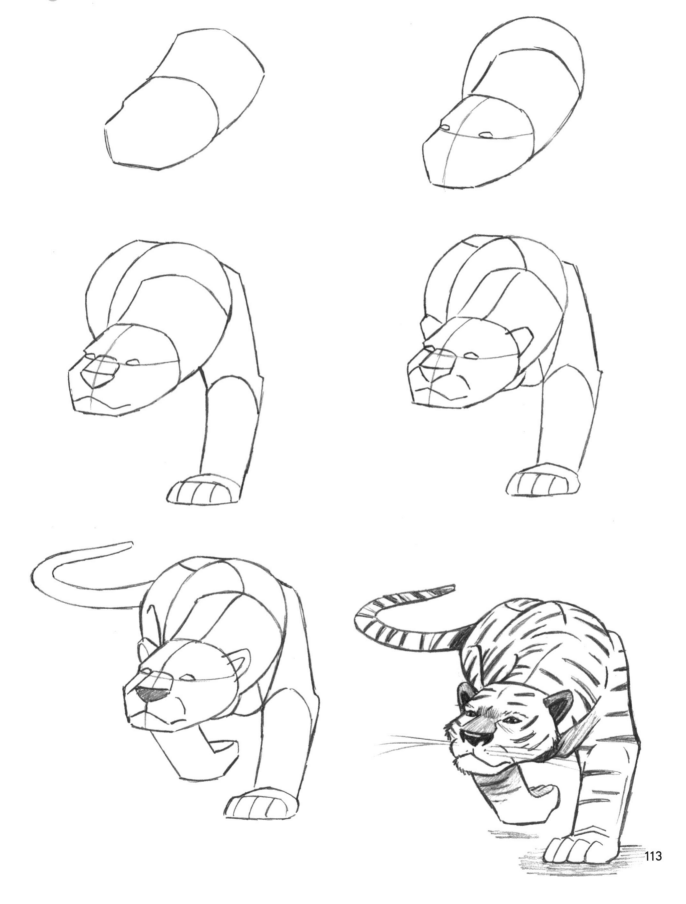

PRIMATES

Primates are very curious animals. They are highly intelligent and sociable, and we can almost see reflections of ourselves in their faces. The chimp and gorilla are most familiar to us. Despite all the different species of primates, the more evolved apes and monkeys usually have several traits in common: a large mouth, a nose that does not protrude from the face (with the exception of the funny-looking proboscis monkey), and eyes that are spaced closely together. Most of them have surprisingly thick eyebrows, which are also a prominent feature. They have short necks, which brings their head close to their shoulders. Therefore, draw the arms and hands of apes and monkeys to indicate their heaviness and large size. This differs from human anatomy, in which the arms, hands, and fingers are smaller and move with more precision and agility.

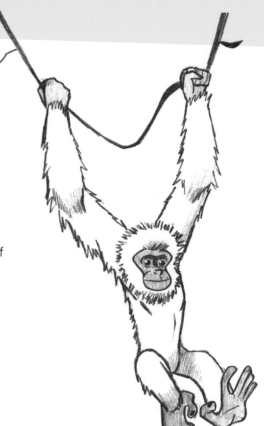

Chimpanzee Face

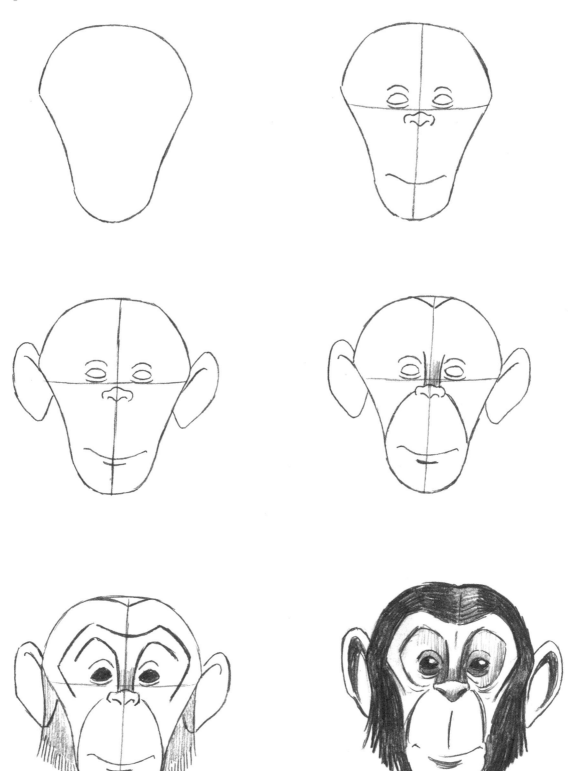

Gorilla

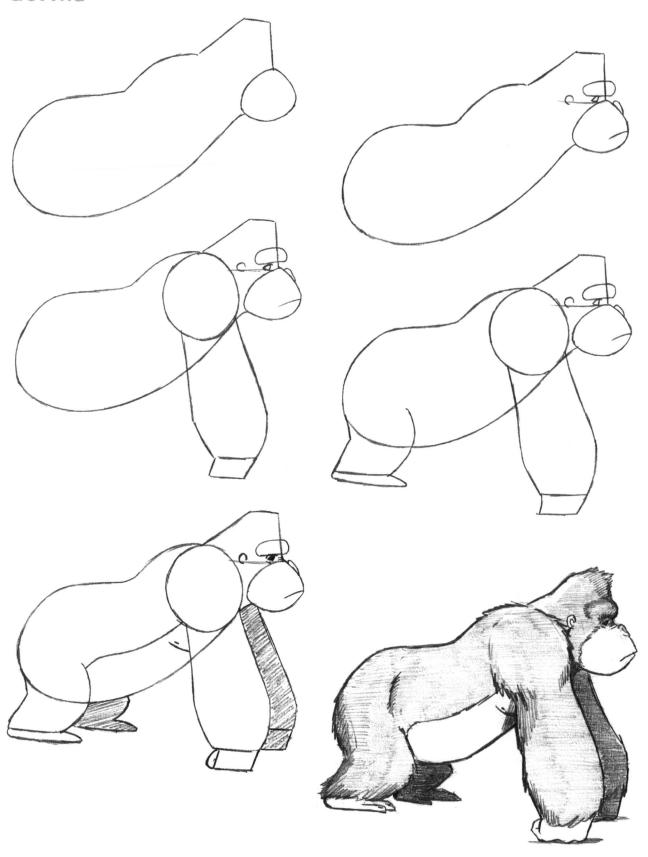

Gibbon

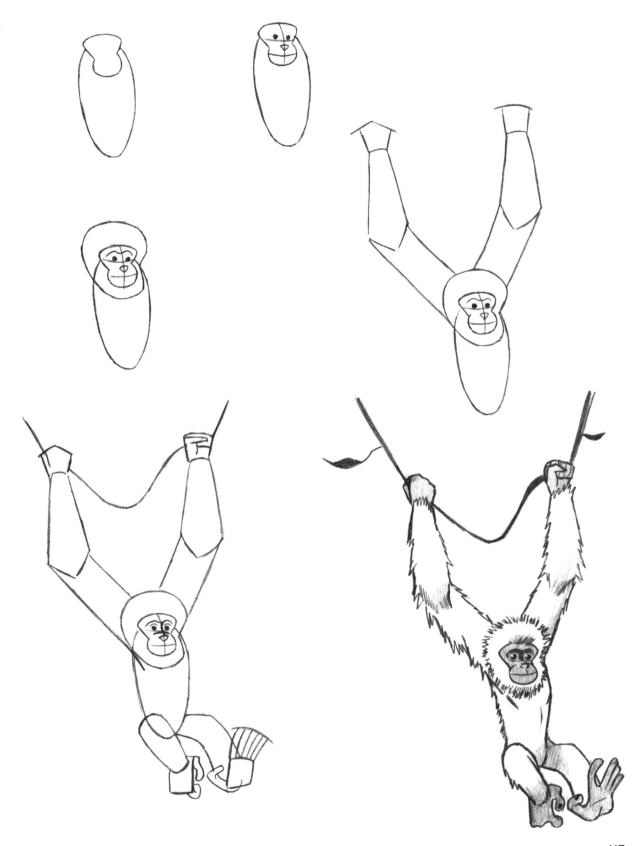

Baboon

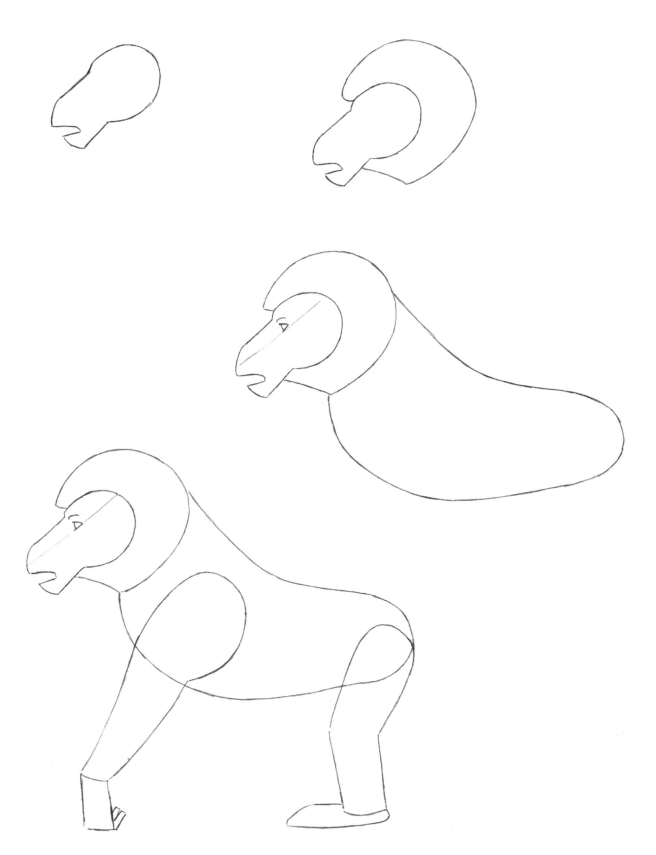

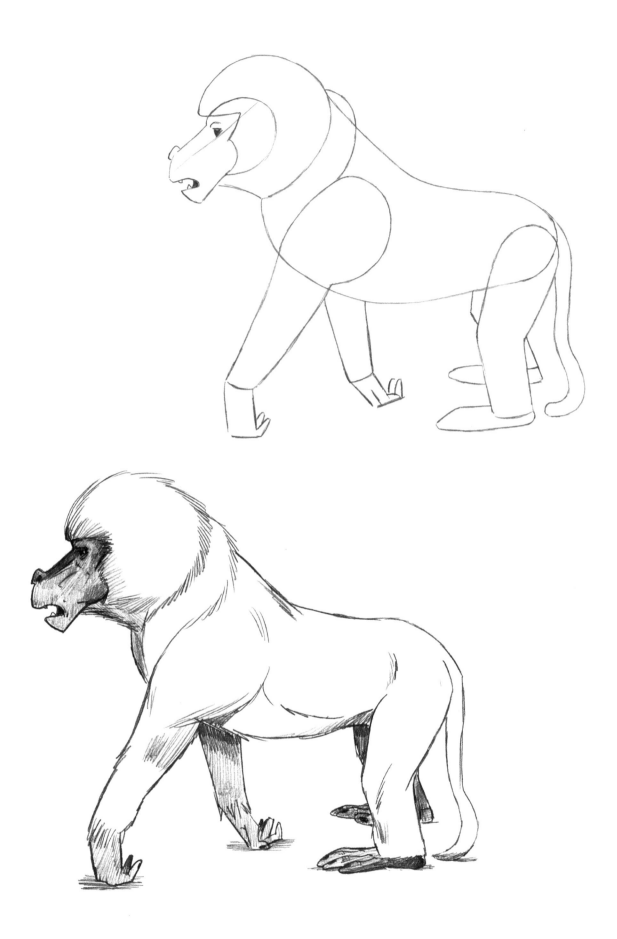

Orangutan

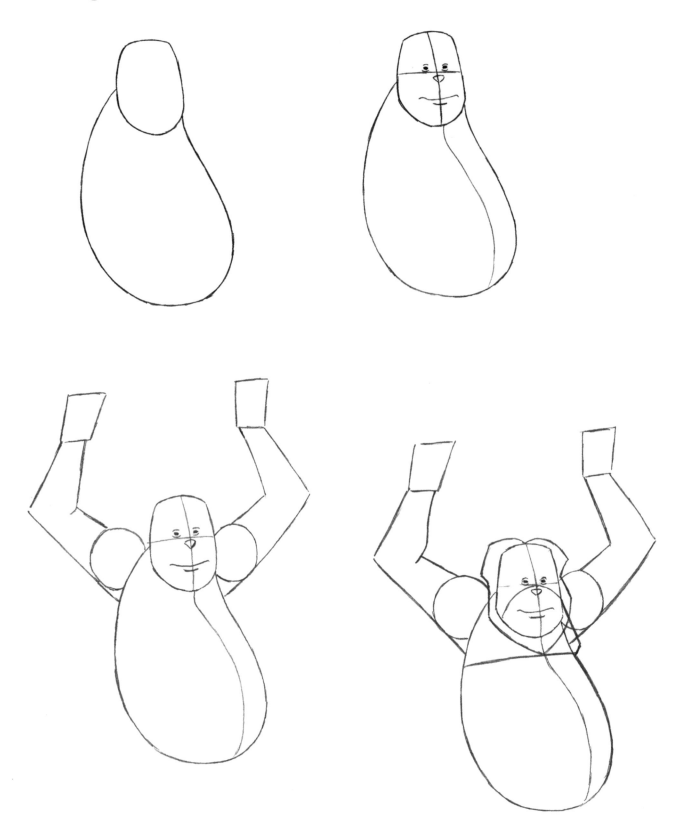

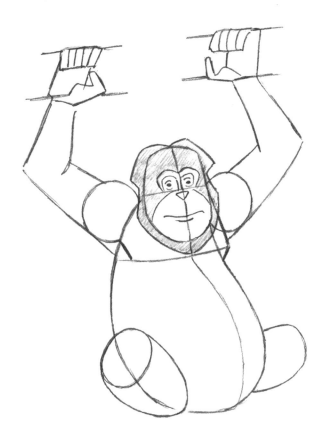

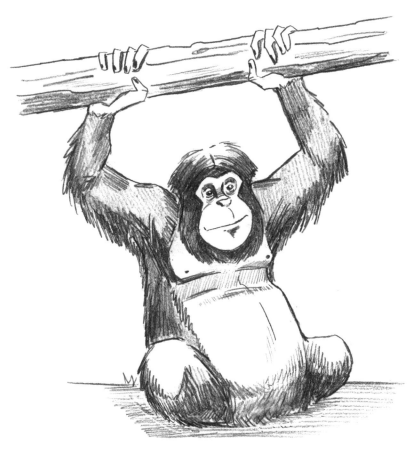

SEA LiFE

The sea is full of mysterious creatures that belong to a world vastly different from our own. Danger can present itself anywhere, at any time, whether it's in the form of a shark, the superpoisonous lionfish, or the giant squid. But the sea is also the domain of many cute and friendly animals as well, like penguins and seals. The animals in this section, which all call the sea their home, are so different from each other that it's hard to offer a general tip for drawing all of them. Rather, we'll address them on an individual basis in the illustrated steps. One thing to note, however, is that the more deadly and dangerous animals tend to have eyes that are dark and empty looking. And one last observation: Each animal has its own body language, shape, and posture. For example, sharks are extra sleek, sea turtles are round and flat, and penguins are husky and compact. Try to accentuate, and even exaggerate, these signature qualities and constructions.

Lionfish

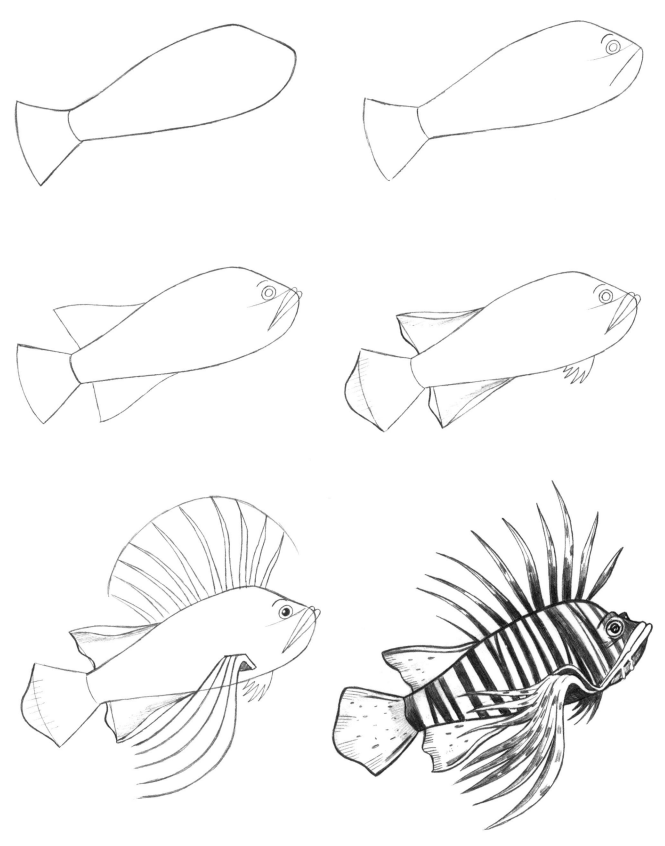

Hammerhead Shark

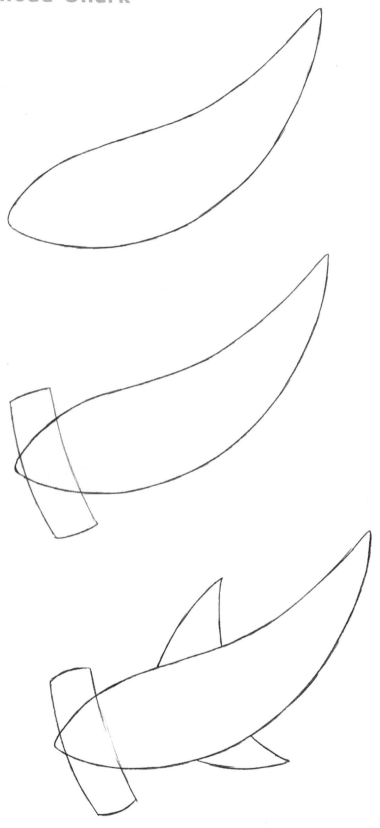

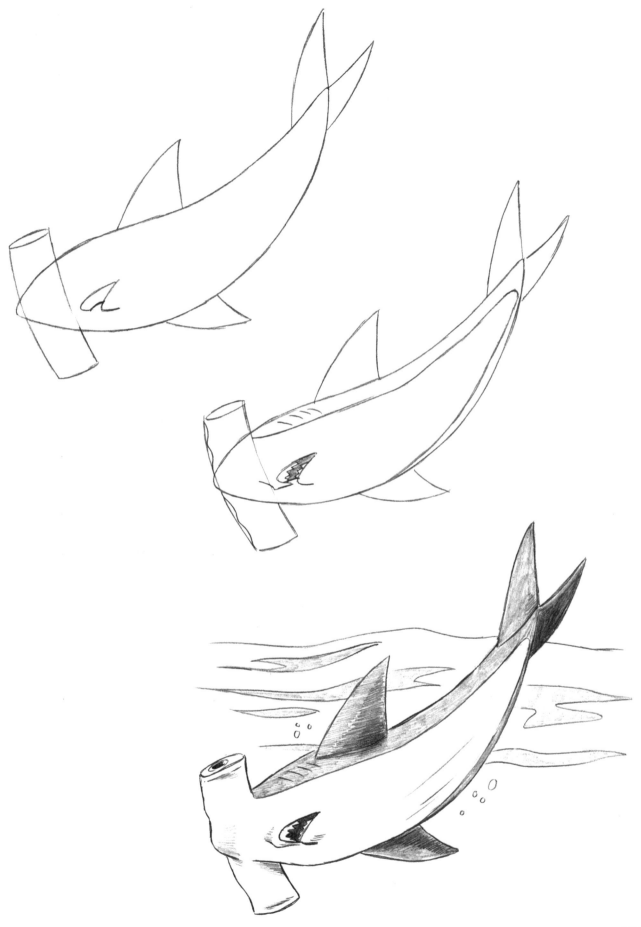

Killer Whale

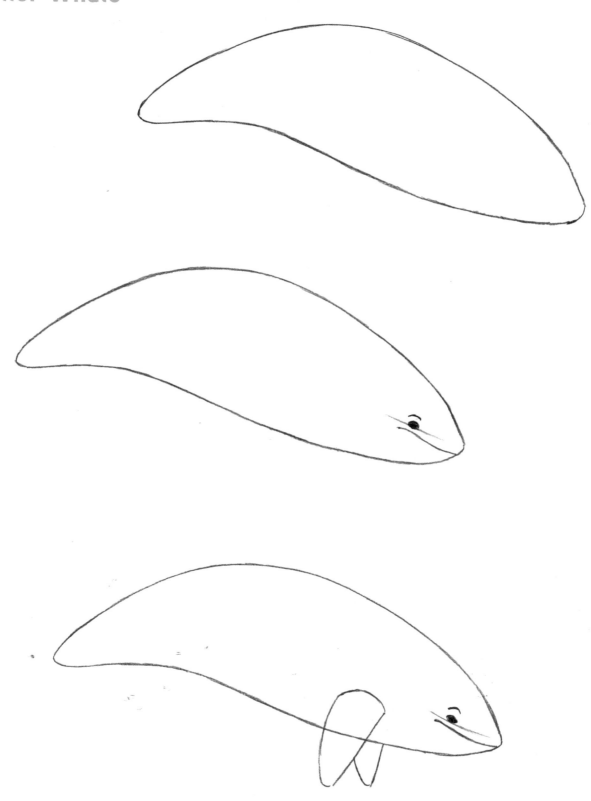

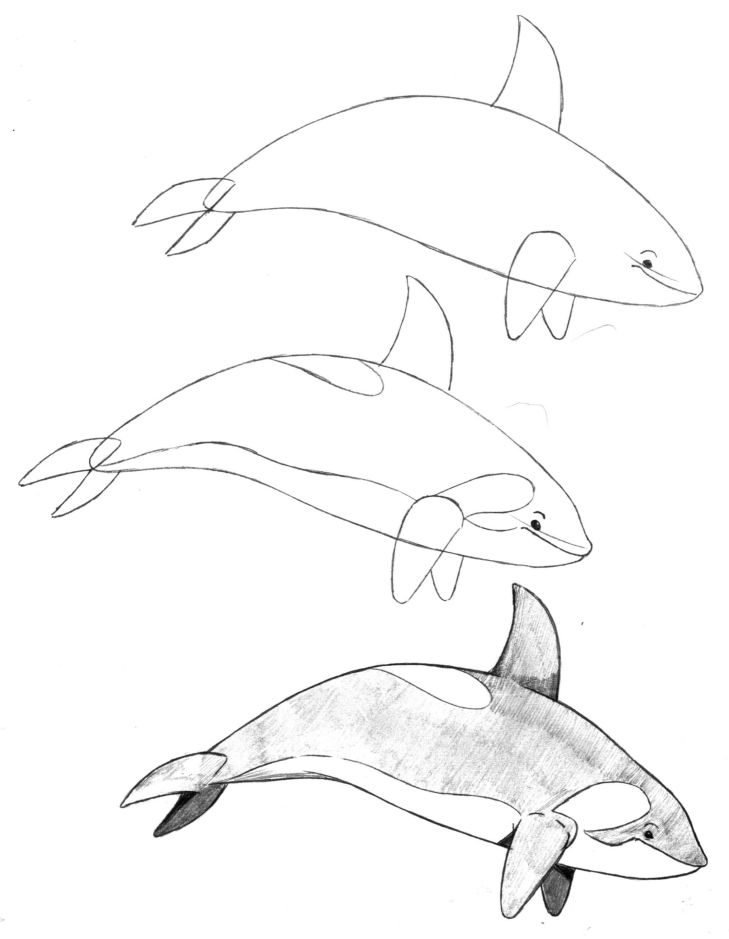

Barracuda

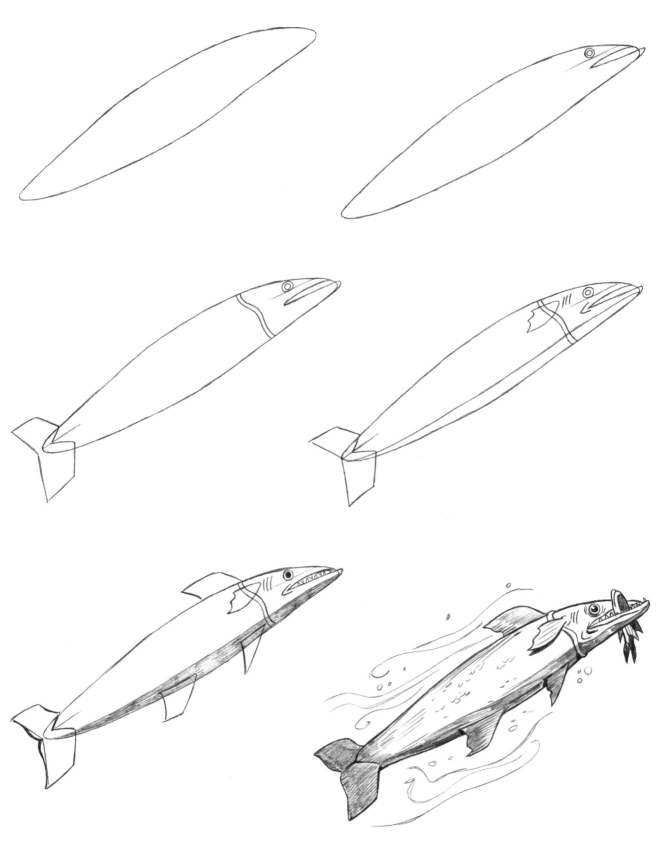

Penguin Dad & Son

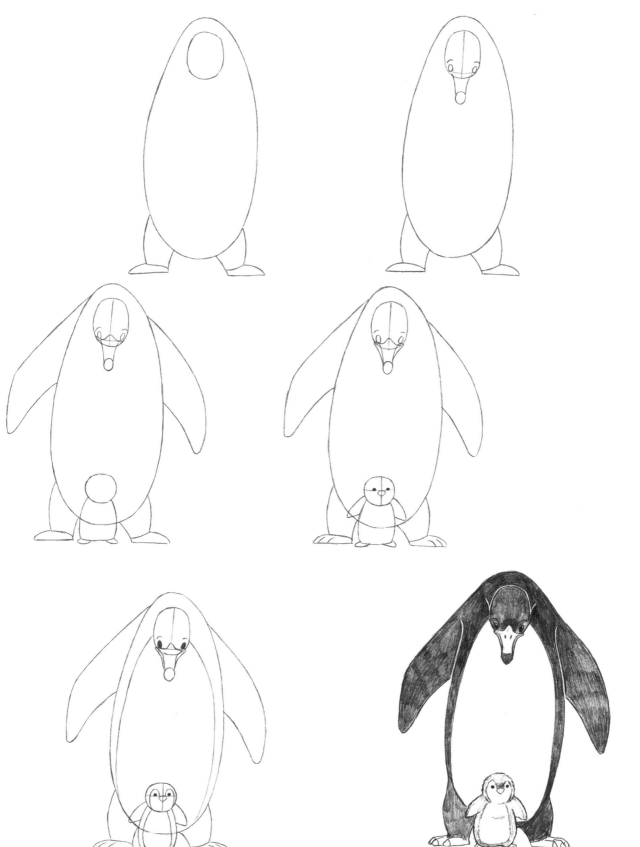

Thresher Shark

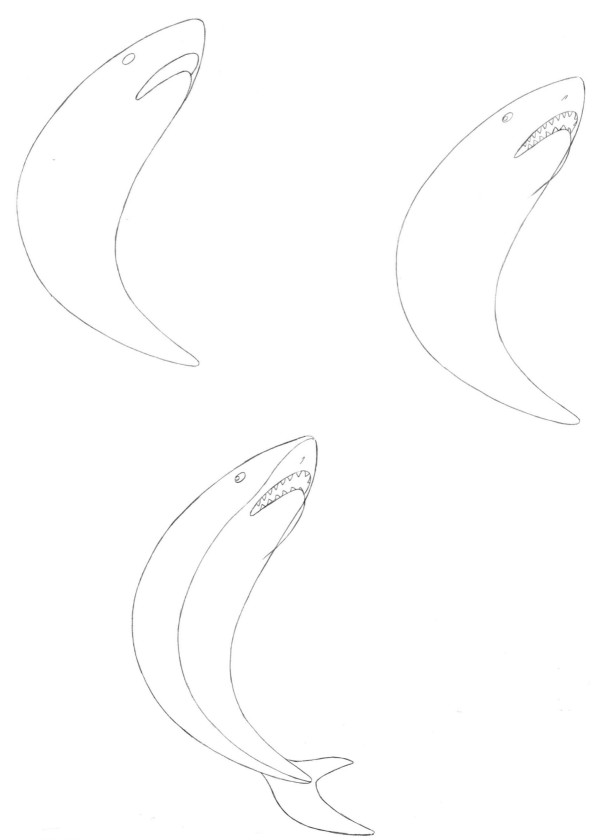

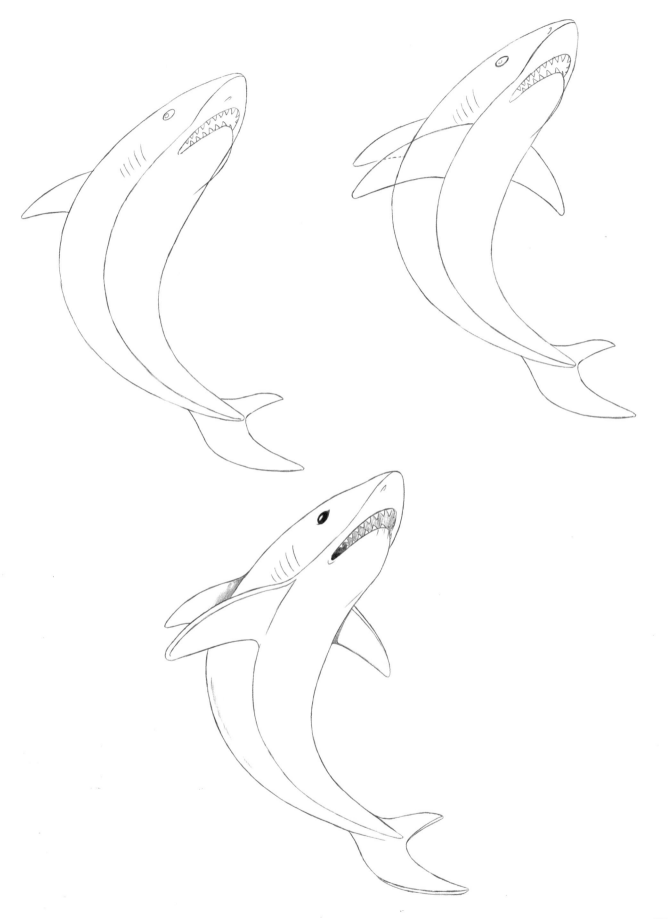

Giant Squid

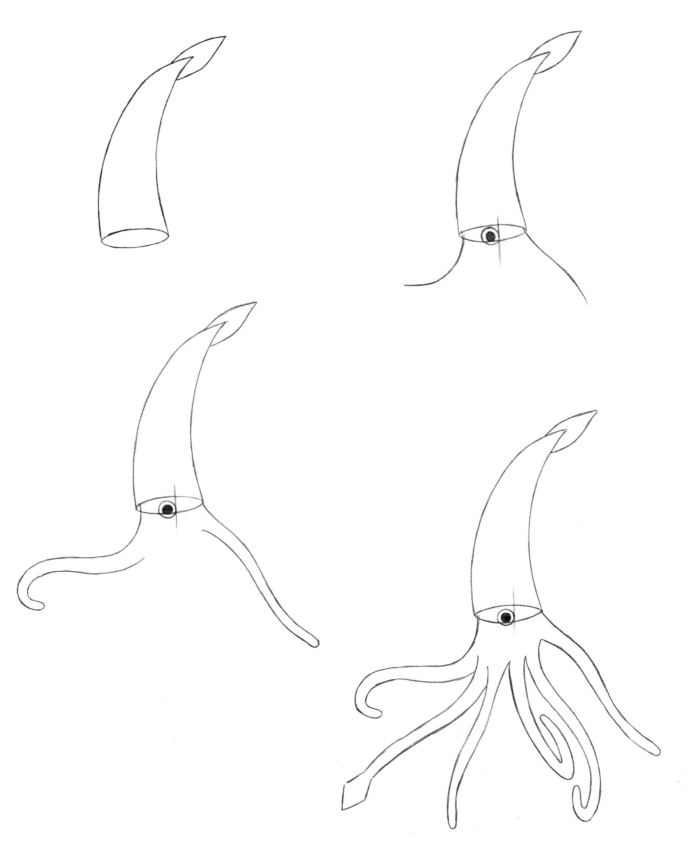

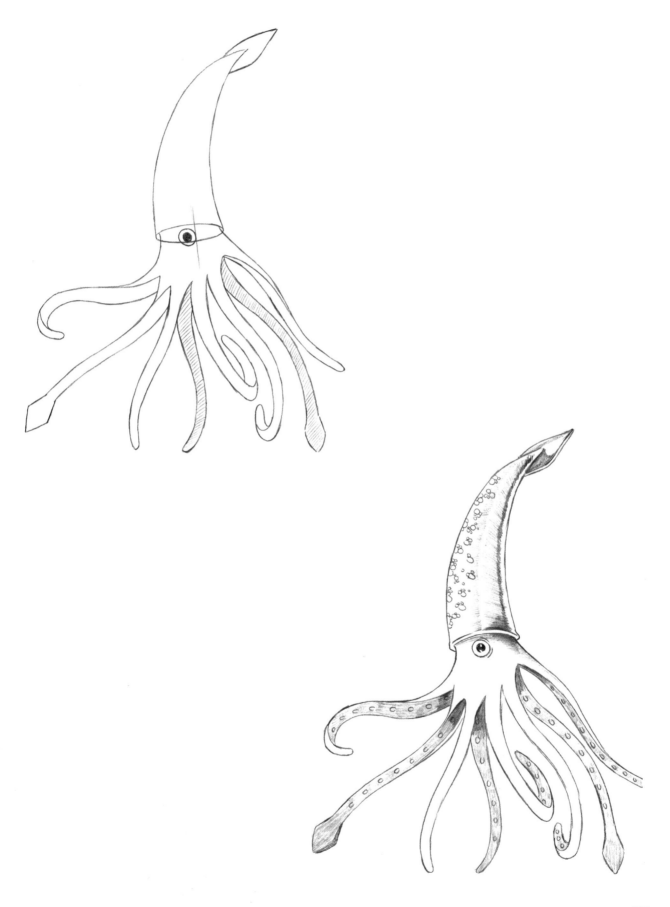

Walrus

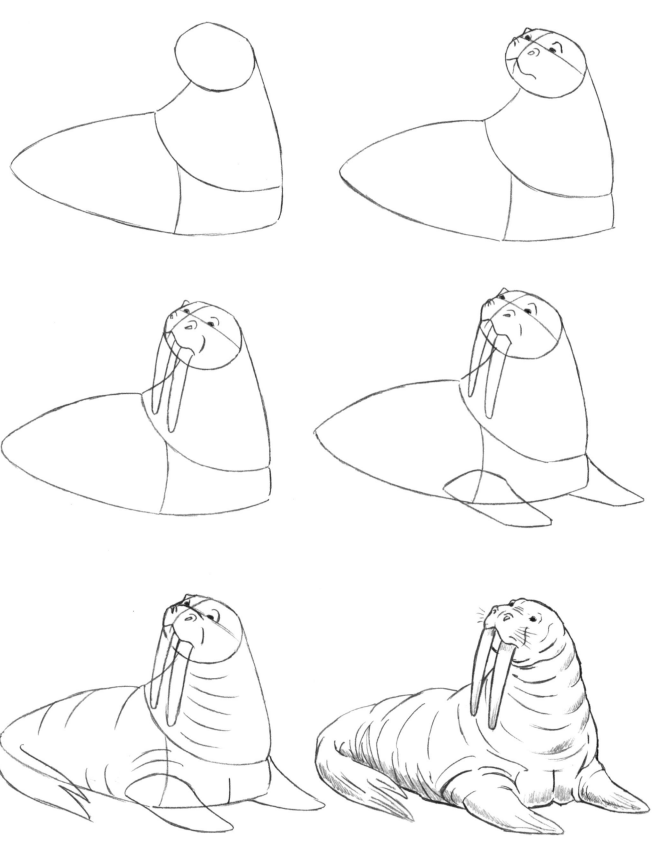

Seal

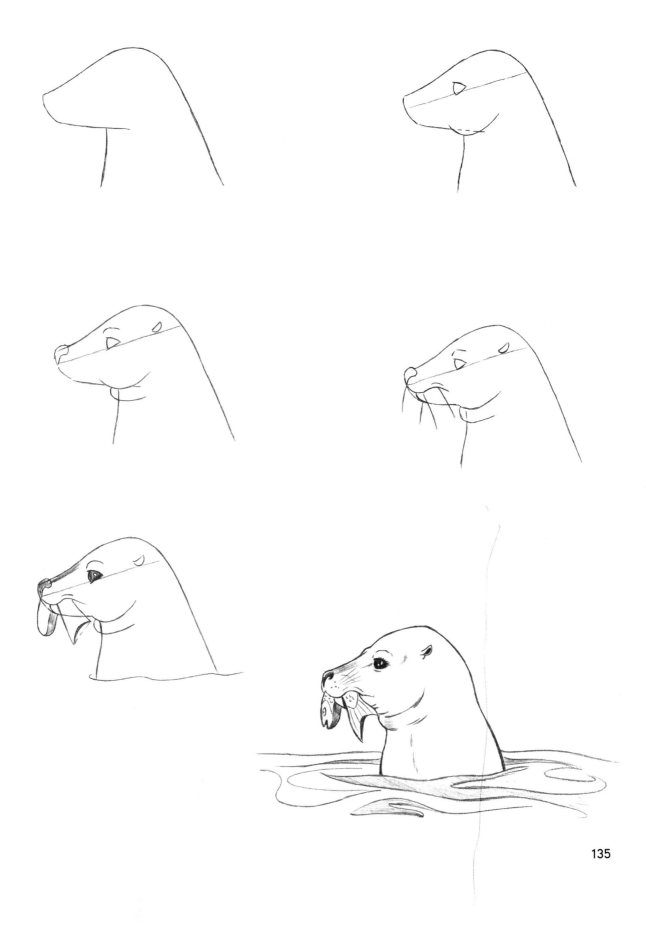

Sea Turtle

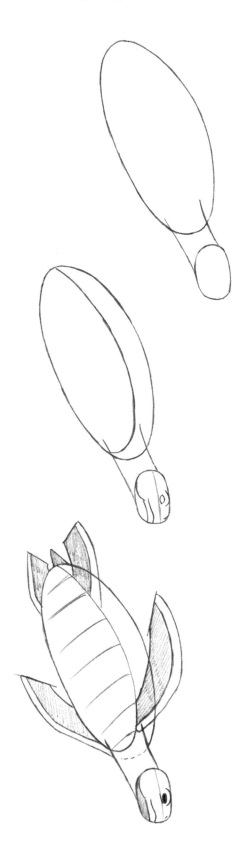

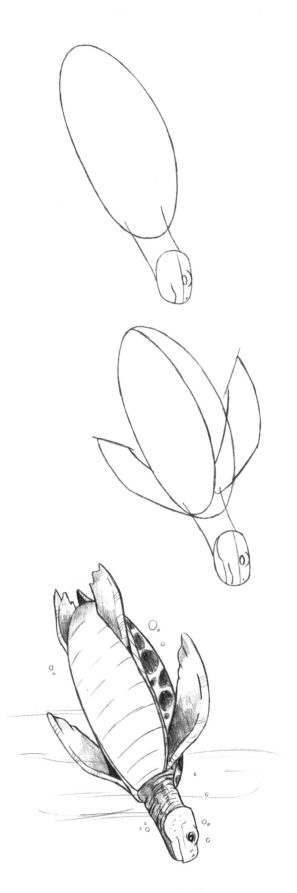

UNUSUAL AND STRANGE ANiMALS

Now we come to the final section, which is filled with oddities of nature—fascinating and curious animals that have unique appearances. I've saved this section for last, because it takes a little extra concentration to draw such unusual creatures. But by following the steps and trusting the guidelines, you'll soon discover that you can, in fact, draw all of these peculiar species.

Remember, this isn't only an instructional book but a good reference for whenever you want to draw any other popular animal; if you can master the basic shapes of the animals in this book, drawing other animals will come more easily.

I want to say thanks for joining me on our little excursion to all corners of the globe in our pursuit of animals to draw. I've had fun, and I hope you have, too. Until next time!

Komodo Dragon

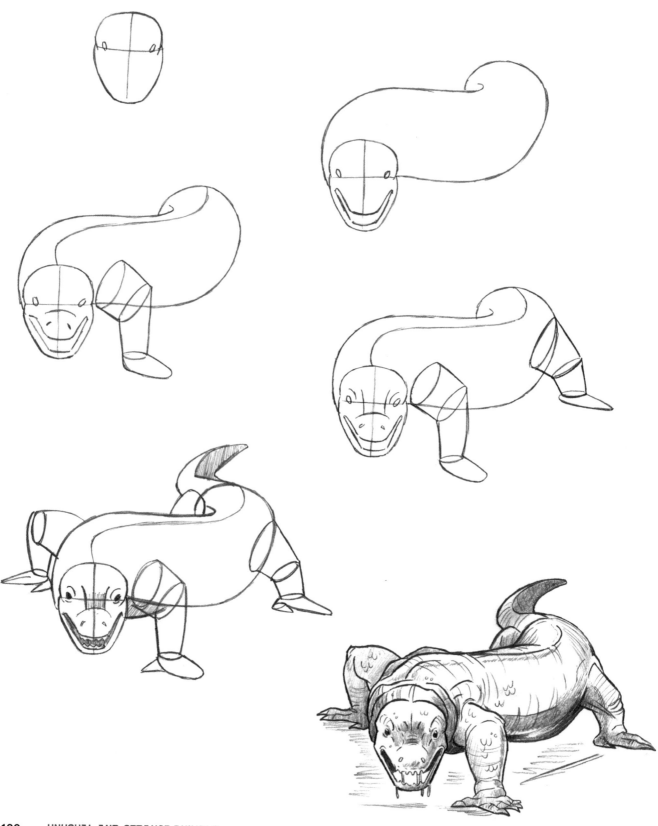

Anteater

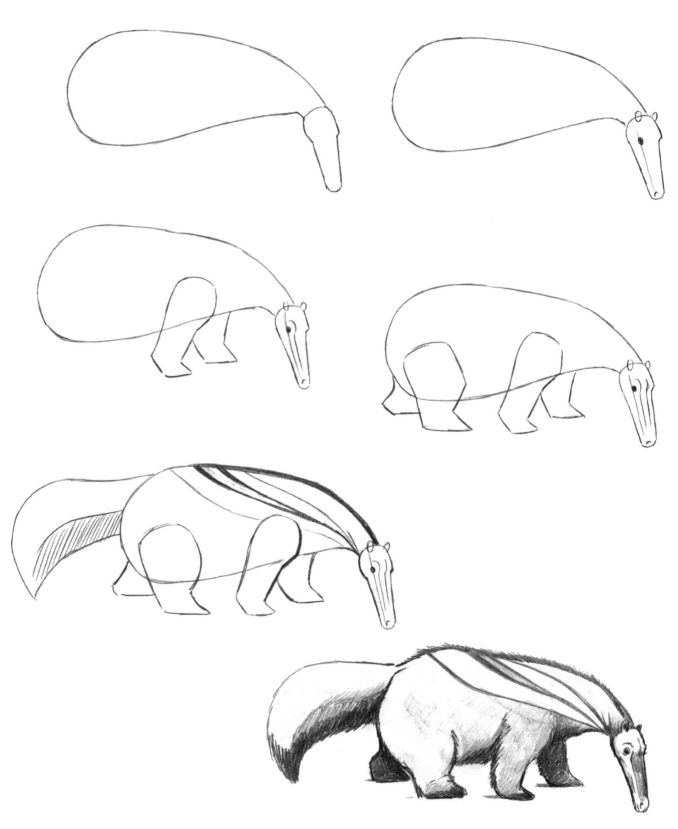

Camel

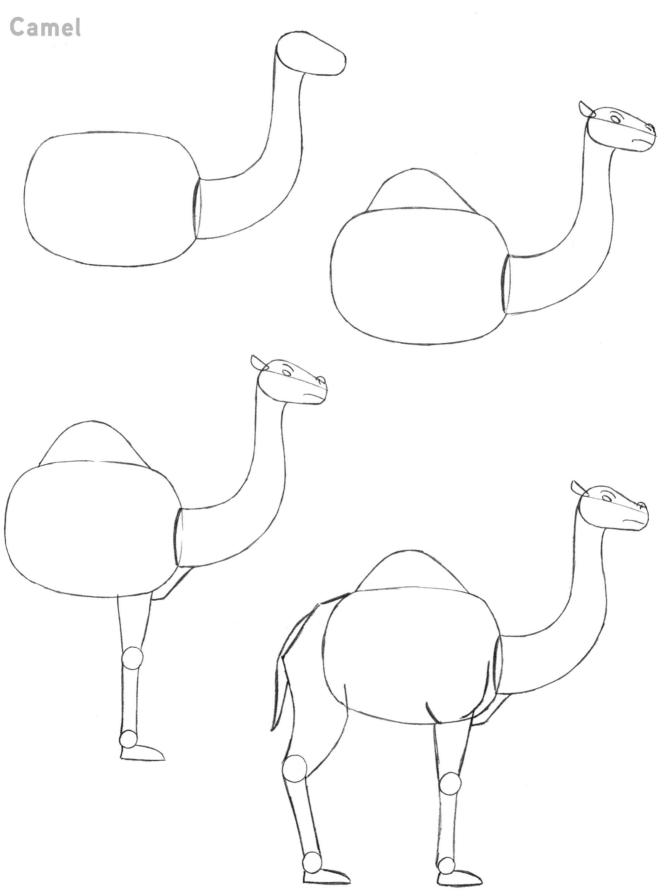

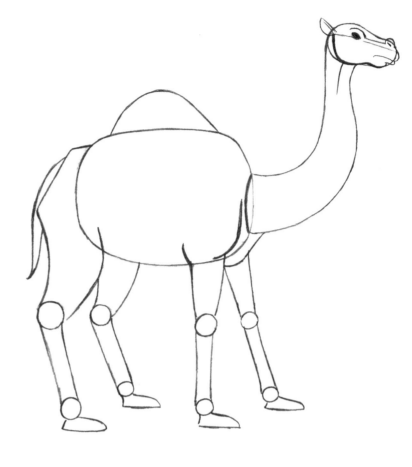

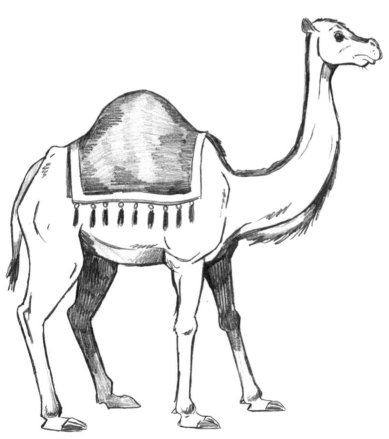

Kangaroo

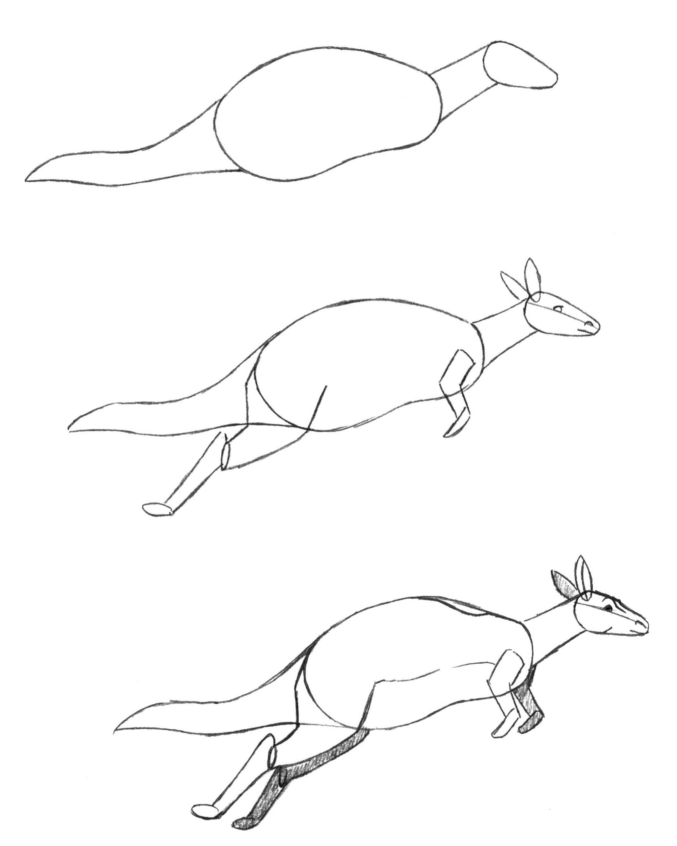

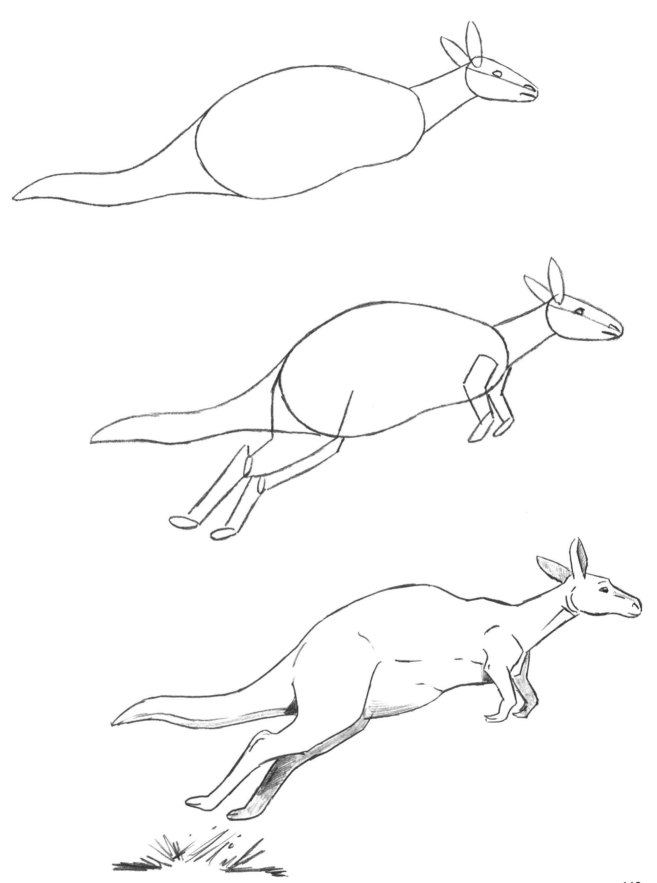

Wild Boar

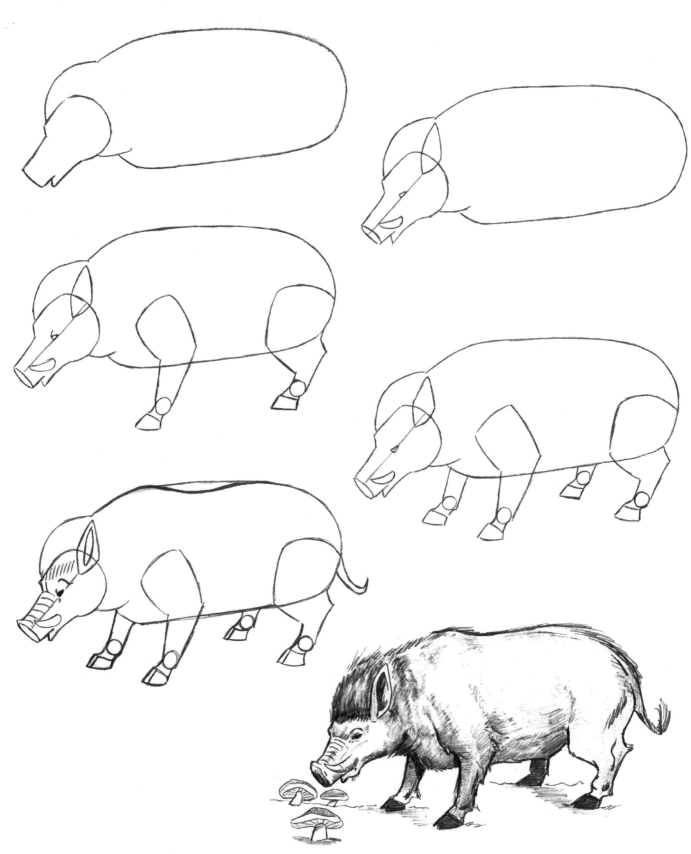